The
UMBRELLA HOUSE

Sometimes, old buildings have so many stories that you can sense the history when you walk past. Sometimes those stories are so powerful that they inspire new ones. That's what happened when author Colleen Nelson lived in New York City and fell in love with the East Village's Umbrella House.

Once upon a time in the real world, an abandoned building became home to a group of people who needed a place to live. These squatters named the building "Umbrella House" and set about fixing it up with scavenged materials and self-taught construction skills. Years later, this building, and others like it, had become their home. The squatters fought for a decade against aggressive eviction attempts by the NYPD and city officials. They used their bodies, their art, and their voices to show the city that they would not be forced out quietly. Umbrella House still stands, but some of the other buildings were lost despite strong community resistance. In 2010, the residents of Umbrella House decided to legalize the building as a low-income co-op and the squatters became homeowners.

In the fictional story you're about to read, Umbrella House finds itself under threat once again—and two young tenants will stop at nothing to protect their home.

The murals on this map are a fictional part of this story, but the physical places are real.

Mural Three
THE
(REAL)
BIG APPLE

Mural Four
UNTITLED

TOMPSON
SQUARE PARK

2nd Ave

1st Ave

Avenue C

EAST VILLAGE

Mural Two
PARADISE
FOUND

East 3rd St

East 2nd St

Avenue A

Avenue B

East 6th St

Mural One
CONCRETE
JUNGLE

EAST HOUSTON ST

FDR DRIVE

TOMPKINS
SQUARE
MIDDLE
SCHOOL

THE
UMBRELLA HOUSE

Mural Five
NOT A CRIME

LOWER EAST SIDE

WILLIAMSBURG BRIDGE

EAST RIVER

Pier 42

Pier 35

N
W E
S

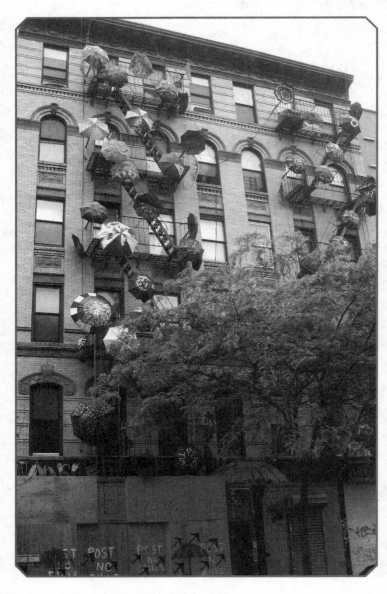

Photo by Salim Virji, CC BY-SA

the Umbrella House

COLLEEN NELSON

pajamapress

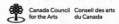

The publisher gratefully acknowledges the support of the Canada Council for the Arts and the Ontario Arts Council for its publishing program. We acknowledge the financial support of the Government of Canada through the Canada Book Fund (CBF) for our publishing activities.

Library and Archives Canada Cataloguing in Publication
Title: The umbrella house / Colleen Nelson.
Names: Nelson, Colleen, author.
Description: First edition.
Identifiers: Canadiana 20230130402 | ISBN 9781772782790 (hardcover)
Classification: LCC PS8627.E555 U43 2023 | DDC jC813/.6—dc23

Publisher Cataloging-in-Publication Data (U.S.)
Names: Nelson, Colleen, author.
Title: The Umbrella House / Colleen Nelson.
Description: Toronto, Ontario Canada : Pajama Press, 2022. | Summary: "Middle-schooler Roxy and her friend Scout join together to stop a real-estate mogul from tearing down their historied New York City apartment building, called Umbrella House. In a contest for a news network, Roxy and Scout use their creativity and video-editing skills to show the value of both their building and their East Village neighborhood. Once they discover the identity of the anonymous Midnight Muralist, Roxy convinces the famed East Village artist to paint the front of Umbrella House to make it too valuable to tear down"— Provided by publisher.
Identifiers: ISBN 978-1-77278-279-0 (hardcover)
Subjects: LCSH: Video journalism – Juvenile fiction. | Historic preservation -- Juvenile fiction. | Middle school students – Juvenile fiction. | Community arts projects – Juvenile fiction. | BISAC: JUVENILE FICTION / Social Themes / Activism & Social Justice. | JUVENILE FICTION / Lifestyles / City & Town Life. | JUVENILE FICTION / Art.
Classification: LCC PZ7.N457Um | DDC 813.6 – dc23

Cover illustration and map by Peggy Collins
Cover and book design—Lorena González Guillén

Manufactured by Friesens
Printed in Canada

Pajama Press Inc.
11 Davies Avenue, Suite 103, Toronto, Ontario Canada, M4M 2A9

Distributed in Canada by UTP Distribution
5201 Dufferin Street Toronto, Ontario Canada, M3H 5T8

Distributed in the U.S. by Ingram Publisher Services
1 Ingram Blvd. La Vergne, TN 37086, USA

Dedicated to
MAUREEN FERGUS
and **JODI CARMICHAEL**

Chapter 1

I grinned at Scout. He'd been my best friend since forever and I couldn't wait to show him what I'd discovered earlier that day.

I typed an address into the search bar of his computer and a moment later a woman with dark curly hair appeared on the screen. Evelyn Pauls was the lead reporter for Veracity News, a current affairs website. She had a reputation for uncovering the truth behind our city's biggest scandals and was my personal hero.

"Too often the news is out of touch with what young people really care about. That's why we're launching the Veracity Young Voices Contest. We want to hear what you have to say. What issues matter to you? What direction do you think our city should take? This is your chance to tell us. Send in a six-minute video that explains your idea. The top

three choices will be posted, and viewers will vote for the winner. The prize? Work with me and the team at Veracity to bring your idea to life as a full-length documentary." She gave her signature sign-off. "This is Evelyn Pauls. Speak the truth. Hear the truth. Find the truth on Veracity."

I clicked pause and looked at Scout. We were in his room, seated at his desk on rolling office chairs.

"Is this for real?" he asked.

"Yes! Can you believe it?" Evelyn was a warrior, out to right the wrongs for people who couldn't do it themselves. She busted dog smuggling rings and exposed corrupt politicians. And now we could win the chance to work with her.

Scout blinked, and a slow smile spread across his face. "So, no adults can enter?"

I'd read the fine print and repeated the important parts to Scout. "You have to be twelve to eighteen years old, residents of New York City, and not related to Veracity staff members."

"We check all the boxes," he said.

Even better, we had experience. Our YouTube channel *EaVillKids*, short for East Village Kids, was about the people and places in our neighborhood. After two years of researching, filming, and editing, our videos looked professional. "Working with Evelyn is the opportunity of a lifetime!"

Scout didn't look up to Evelyn the same way I did, but as a videographer he respected her crew's camerawork. "First, we have to make it into the top three," he reminded me. "Can we pitch something we've already done for *EaVillKids*?"

I shook my head. That had been in the fine print too. "It has to be original, unpublished content." None of our videos had the edge a Veracity story needed anyway.

"When's the deadline?"

"Three weeks," I told him. "Lots of time."

Scout groaned. "Three weeks? That's not 'lots of time,' Roxy."

A short time frame didn't dampen my enthusiasm. "Maybe that means not as many people will enter. Chances like this don't come around every day. We have to jump at it." I didn't need to add that we lived in one of the most eclectic neighborhoods in New York City, or that stories lurked around every corner. All we had to do was find the right one. I pulled out the notebook we used to brainstorm for ideas. "So? Is it a yes?"

Scout knew it was pointless to argue once I had my mind set on something. He'd barely nodded before I flung my arms in the air. "Veracity News, here we come!"

As we walked home from school the next afternoon, the sun shone, and the sky was a bottomless blue. It was the kind of spring day that gave me hope summer was coming. Scout and I had been bouncing Veracity video ideas back and forth, but nothing felt right.

"Maybe we're overthinking it," Scout said. A familiar crease appeared between his eyes. "Maybe we should just do what we're good at and take Evelyn on a tour of the East Village. We can show her the places that matter to us."

I stopped where I was and surveyed the street. To my right was Disdressed, a vintage clothing store owned by our neighbor Ulli. I could see a flash of her pink hair through the window. Next door was the entrance to Hooligans, a bar that claimed to be the birthplace of punk music. Its metal door was covered with graffiti. Across the street a few people had gathered outside Vinyl Trap to flip through the crates of records, and farther up the block was the gallery owned by Scout's mom, Amanda. At the end of the block, painted on the side of a building, was one of the famous East Village murals. They were painted in secret, and the identity of the Midnight Muralist was still a mystery.

I followed Scout's gaze up and down the street. "These places matter to us because this is our home. How are we going to make them matter to Evelyn? Or to a wider audience? We need more of a story, something for people to connect with."

At the next corner, we turned right and our four-story, red brick building, nicknamed Umbrella House, came into view. It was hard to miss because of the colorful umbrellas decorating the fire escapes out front. Umbrella House is one of eleven former "squats" left in the East Village and has a legendary history. Scout and I had heard it so many times, we had it memorized.

It went like this: There was a time when landlords stopped maintaining and paying taxes on their buildings, so they left them abandoned. The city came along and cut holes in the roofs and filled the pipes with cement, figuring that would stop people from squatting, or moving in illegally. It didn't work. People needed a place to live, so they used sledgehammers to smash the cinderblock doors. They were even willing to walk around inside with umbrellas when it rained because a leaky roof was better than no roof at all.

Some of the squatters started to fix up the buildings, which is what happened at Umbrella House. It took years, but the roof was patched, the plumbing was repaired, and eventually, electricity was restored too.

As the squatters transformed the building, the city tried to kick them out, claiming they had no legal right to live in it. The squatters went to court and argued that since they'd made so many improvements with their own money and labor, they should be allowed to stay. The judge agreed, and the squatters paid one dollar for each apartment in the building! About ten years after that, Umbrella House became a co-op, which made everyone an equal owner of the building.

Three of the original squatters still lived at Umbrella House. My grandma, Selena, was one of them. So were Lenny Rizzoli in 1B and, across the hall, Jose Pedro Ortiz, an artist whose name everyone shortened to Ortiz. They were as much a part of the building as the brick-and-mortar walls.

I dug my key out of my pocket and unlocked the front door. With its gleaming wooden banister and freshly painted walls, it was hard to imagine Umbrella House had once been run-down. Lenny arrived just after us. As usual, he was grumbling about something.

"Look what just got posted on *The East Villager* website," he said, holding up his phone. Lenny's voice was distinctive. After too many shows as the lead singer in a punk rock band, he sounded like someone had taken sandpaper to his vocal cords. He didn't just

sound like an aging punk rock singer; he looked like one too. He had bleached-out blond hair and wore a studded leather vest all year, even when the humidity hit 100 percent in the summer.

Scout took the phone from him and read the headline. His eyebrows shot up. "Closing? When?"

"End of the month!"

"What is it?" I asked, looking over Scout's shoulder. "Beloved Business Bids Farewell," I read out loud. "Hey, that's Laugh Emporium! It's closing?" The gag and party store was next door to Umbrella House.

Lenny scowled as I scrolled farther and read the article out loud.

"The East Village is set to lose another of its legendary businesses. The latest store to close is Laugh Emporium, which sells everything from helium balloons to itching powder to piñatas. It has been owned and operated since the 1950s by the Kricklewitz family, who also rent the apartment on the second floor. 'The new building owner wants me out. This is a war I can't win,' Walter Kricklewitz said.

"According to sources, Richard Van Newell of Gotham Development Corporation recently purchased the building and decided not to renew Kricklewitz's lease. While no plans have been

finalized for the space, the building will likely be torn down."

I gasped. I couldn't help it. Mr. Kricklewitz was an East Village institution. Everyone knew him. He was full of surprises and loved playing tricks on people. He called it getting "Kricklewitzed." If the article about the sale of his building hadn't been on *The East Villager*, I'd have thought it was another one of his pranks.

"Those developers have no respect for what made this neighborhood." Lenny shook his head in disgust.

"Was the store not doing well?" Scout asked. "It always seemed busy."

"It was doing fine!" Lenny exclaimed. "The real estate weasels make it impossible for a store like his to stay in business. They want us, all of us, out!" With those words, Lenny left, clomping up the stairs in his combat boots.

Scout and I exchanged looks. We were used to Lenny's rants, but this one had hit close to home. I didn't want to see Laugh Emporium close, and I really didn't want to say good-bye to Mr. Kricklewitz.

CHAPTER 2

I was in my room rewatching videos on Veracity's YouTube channel, hoping for some inspiration. I'd gone through the list of possible topics in my notebook, but nothing jumped out at me. We did goofy stuff for *EaVillKids*, like punk makeovers at Disdressed and daring each other to eat the spiciest chili peppers at the Mexican cantina. None of those ideas worked for Veracity. We needed something impactful; something that would get us noticed.

"Roxy?" Grandma called. "You home?"

"In here," I answered.

On weekends, Grandma sold vintage furniture from her stall at the flea market. During the week, she sourced out pieces for set designers, or for her

online store. Grandma hustled—hard! She was always working to find creative ways to make money for us.

One of the reasons I connected with Evelyn was that, like me, she'd been raised by her grandparents. She credited them with giving her the guts to follow her dreams. One day, I wanted to say the same to Grandma—that I got where I was because of her. If Evelyn picked our video, and we won the Veracity contest, it would be the first step to making that happen.

Grandma stepped into my room, and I scooted over to make room for her on my bed. Just like always, she touched her fingers to her lips and tapped the photo of Dad that sat on my bedside table. She did it so often, the glass was permanently smudged with her finger-prints. My father died when I was two years old in a car accident on an icy highway. Even after ten years, we felt his absence. Glancing at his picture, I got the familiar pang of wondering what our lives would be like if he was still around.

"What are you working on?" Grandma asked as she stretched her legs out beside mine. "Something for *EaVillKids*?"

"Trying to come up with ideas for the Young Voices Contest," I said, sounding as disheartened as I felt.

She moved closer and put her arm around my

shoulders. The bracelet I'd given her for Christmas glinted. I'd bought it from a jewelry designer at the flea market. There'd been one with hearts on it, but Scout had been with me and reminded me that Grandma's name, Selena, meant *moon*, so I'd bought that one instead. It was her favorite piece of jewelry, and she never took it off. She said it was special because every time she looked at it, she thought of me.

"What do you have so far?"

"Nothing! Literally nothing," I said, showing her the blank page in my notebook. I didn't usually have this much trouble coming up with ideas. So much was riding on it! And now my idea well had dried up. "I want it to be personal and original, but still meaningful. Viewers need to care about the story as much as Scout and I do."

"That's a tall order."

"I know."

Grandma gave my shoulder a squeeze. "Why don't you make a list of the things that matter to you and see if anything works. You could do a video on me if you want."

I loved Grandma, but there was nothing Veracity video-worthy about her life. I thanked her anyway and got back to brainstorming.

Scout and I walked to and from school together every day and we had our morning departure perfectly timed. Scout listened for my apartment door to close. By the time I walked down the flight of stairs to the second floor, he was waiting in the hall.

"Want some help?" I asked. He was trying to shrug on a zip-up hoodie while holding half a bagel and carrying his backpack.

"No fank oo," he answered, stuffing the bagel into his mouth. He performed some kind of contortionist routine, and by the time we got to the bottom of the stairs, both arms were in his hoodie, his backpack was secure on his back, and the last bite of bagel had disappeared.

"Any ideas for the video?" I asked, pushing the front doors open. The first burst of morning air was pure East Village—damp cement mixed with a hint of garbage and exhaust fumes.

"None," he said, sounding defeated.

"That makes two of us." Had the idea well really dried up? Right when we needed it the most?

We'd only taken a few steps toward school when Scout groaned. "When did *that* happen?" He pointed

at the front of Laugh Emporium. A clumsy graffiti message had been sprawled under the window.

Stop Gentrification!

"Poor Mr. Kricklewitz," I said, shaking my head. It was bad enough he'd been forced out of his home and had to close his business, but did he really need to deal with vandalism? At that moment a loud burp sounded. It wasn't from a person though. It was the door chime of Laugh Emporium. Instead of a jingly bell, it was programmed to make all kinds of disgusting noises.

"How's *that* for a 'good morning?'" Mr. K asked, pointing at the graffiti. Normally, his infectious laugh could be heard echoing up and down the block. Not today. News about the sale of his building had left him looking worn out. He had a broom in his hand. His sidewalk was the cleanest on the block, thanks to all his sweeping, which was just an excuse to hang out and talk to people.

"It sucks," Scout said, meaning the graffiti and everything else too. Neither of us wanted Laugh Emporium to close, or Mr. K to move.

"Do you want help painting over it?" I asked. There were other patches of mismatched color where

he'd covered tags. Mr. K took a lot of pride in the exterior of Laugh Emporium.

He blew out a puff of air. "I'm not painting over it! My lease says I can change the face of the building as I see fit. I hope that developer sees the message before he tears down the building." I wasn't used to hearing Mr. K sound so angry. He whisked his broom at a few cigarette butts, sending them to the sewer. "That's why I did it."

I glanced at Scout, not sure I'd heard right. "*You* did it?"

"That's what I said." When he looked at us, there was a familiar gleam in his eye. "Van Newell got Kricklewitzed." He chuckled. "Spray paint's inside in case you want to leave a message too."

Scout arched an eyebrow at me as a slow smile spread across his face. The answer was obvious. A wet fart noise sounded as Mr. Kricklewitz disappeared inside, returning a moment later carrying two cans of spray paint.

"What are you going to write?" Scout asked.

"I'm not sure yet." I looked around, hoping for inspiration. There was no shortage of graffiti on the buildings around us. The metal storefront security gates were covered with tags and colorful lettering. I was no artist, so whatever I did had to be simple. Scout went first.

EV 4 EVER

"East Village Forever. Not bad," Mr. Kricklewitz said, nodding his approval.

It was my turn. I gave the can a shake. The metal ball inside knocked against the can. I hesitated just before I pressed the nozzle. Even though Mr. K had given me permission, it still felt wrong to deface someone's property.

But what Van Newell and his company were doing was worse. They weren't just defacing, they were destroying. I didn't have the finesse of a real graffiti artist, but it was the message that counted. I stood back and looked at what I'd written. It was my signature *EaVillKids* sign-off.

Stay Real! Stay EaVill!

Mr. Kricklewitz hooted in appreciation. "I love it!"

I gave him back the spray paint. "Tell your friends! The more messages, the better!" he shouted after us as we hurried to get to school on time.

Tompkins Square Middle School, or TSMS, sat at the corner at E. 6th and Avenue A. It had bright red doors and student artwork in all the windows. The bell

rang just as we ran up the front steps. I had drama first period, and Scout had visual studies—his favorite class. "We get our photography portfolio marks back today," Scout told me when we got to our lockers.

"You nervous?" I asked teasingly. His teacher, Mr. Clovis, was tough, but when it came to the visual side of things, Scout was as much a natural behind the camera as I was in front of it.

"I mean..." he drifted off and I could tell the answer was yes, which was ridiculous. No matter how many times I reassured Scout he had legitimate talent, he still doubted it. Maybe a good mark from Mr. Clovis would finally prove to Scout that I was right.

I shook my head at him and slammed my locker shut. Thoughts of Mr. K and Laugh Emporium swirled in my head as I waved good-bye to Scout and went to class. Between worrying about his future and our Veracity video, concentrating in class was going to be tough.

CHAPTER 3

Once a month we had tenants' meetings, which weren't as boring as you'd think. There was food, and sometimes the meetings turned into karaoke parties, or game nights. At the very least, I was guaranteed a few good stories from Grandma, Ortiz, or Lenny about the early days at Umbrella.

When the weather was nice, like tonight, we met on the roof. It wasn't a regular, asphalt-covered surface like most of the rooftops around us; ours had been turned into a garden. There were raised flower beds, a vegetable plot, and lots of patio chairs. We'd just planted the seeds a few weeks ago. Little green shoots sprouted up from the soil. By the end of summer, some of them would be taller than Scout and me. Up here, in our garden oasis, it was easy to forget that a bustling city existed below.

Monique, Scout's *maman*, and the Chair of the Tenants' Committee, ran the meetings. She was petite but had a commanding presence. With her sleeve of tattoos, she didn't look like a typical buttoned-up lawyer. "There's one more item of business," she said. "The apartment building next door has been sold." She looked in the opposite direction of Laugh Emporium. Seventeen Avenue C was three stories tall and run-down.

There was a collective groan. *Another building bought by a developer?*

"Who bought it?" Grandma asked.

"Gotham Development," Monique said. She'd barely got the name out when Lenny jumped in.

"Wait a minute. Gotham Development? That's the company that bought Laugh Emporium!"

Monique nodded. "I did some digging. The owner of the company is Richard Van Newell. He has the same *modus operandi* as the other developers. He kicks out tenants, tears buildings down, and replaces them with something new—and expensive."

"Gentrification!" Lenny blurted. "That's what this is! They'll push us out of the neighborhood we built!"

"Should we be worried?" Miguel asked, sitting up straighter in his chair. He owned a bookstore near St. Mark's Square. He'd also been my dad's best friend and spent so much time at Umbrella House he'd practically

grown up here. He'd officially moved in five years ago and this building meant as much to him as anyone. "If this Van Newell guy owns the buildings on either side of us, won't he want to buy Umbrella House?"

Monique hesitated, choosing her words carefully. "I'm sure he *wants* to; the question is, can he? Because Umbrella House is a co-op, he'd have to get the City Council to pass a law dissolving our rights. Which," she cast her eyes around the group of us, "he might try. He has a lot of clout with some of the councilors."

That comment got an even louder round of groans. Words like *unfair* and *typical* were thrown around.

"I miss the days when everyone thought this neighborhood was just a bunch of squatters and wanted nothing to do with us." Grandma sighed.

Beside Scout, Amanda nodded. Her long, dark hair was coiled up in braids. I didn't know if all gallerists were on the cutting edge of fashion, but Amanda was. In her work outfits she looked like she'd just stepped off a runway. "I hate to say it, but if this keeps up, the East Village is going to be a shell of what it was. I've already noticed a different vibe at the gallery."

She was right. The East Village *was* changing. Stores that had been open forever, like Laugh Emporium, were closing. There were For Lease signs all over, and empty lots where buildings had been torn down. There was

lots of new construction too and the metal and glass designs always looked out of place.

"We can't sit back and do nothing," Ortiz said. "That's not the East Village way." Like always, Ortiz, my self-proclaimed "funcle" was in a pair of paint-spattered overalls. He peered at us through thick-framed glasses that were so ugly they were stylish.

"The good news is, Van Newell hasn't made a move yet. We have time to make sure our voices are heard." Monique passed around a paper with contact information for City Council members. "Write letters, phone them, send e-mails to let them know you're concerned."

This was a lot more serious than a usual tenants' meeting. Could Umbrella House really be in danger?

I caught Scout's eye across the roof and wondered if he was thinking the same thing as I was. The video for the Veracity contest had to be meaningful and original; a story that mattered to us and to viewers.

East Village wasn't just *another* neighborhood. It was the place where artists, musicians, and writers came to create. All that creativity brought an energy—a feeling like anything could happen here. If we could communicate that in our video *and* explain why Umbrella House was important and needed protection, we might have a shot at winning the competition.

"This is what I have for the opening so far," I said. I was sitting cross-legged on Scout's bed with my notebook open in front of me. I'd pulled my hair up into a topknot, but a few coppery curls escaped. Using my best reporter's voice, I began. "The umbrellas decorating the front of our building aren't the only reason it's called Umbrella House. If you ask one of the long-time tenants, like my grandma, she'll tell you it's because of something else." I looked to Scout for his reaction. "And then we'll cut to Grandma explaining what she's told me before. Umbrella House protected the tenants; keeping them safe the same way an umbrella does when it rains."

Scout slapped a hand on the desk in approval. "Yep. That's it," he said. "That's the idea."

I breathed a sigh of relief. *Finally!* "I was thinking we could interview Lenny and Ortiz about what it was like in the early days. Maybe Miguel too." It felt like we were really onto something.

"I could take some aerial views with the drone." Scout's suggestion made me smile. The drone had been his twelfth birthday gift and he always found an excuse to use it for a video. He paused for a moment. "You know what else would be cool?"

"More drone footage?" I teased. My pencil was poised over my notebook. Sometimes, our ideas came so fast I had a hard time getting them all down.

"Mixing in old photos to show how Umbrella House and the neighborhood have changed. I could try and find some online."

I wrote the idea down. "Grandma has lots of photos. They're all stuffed in a drawer. I'll research more about Umbrella House's history...." I drifted off, wondering where to start.

It was great to have the idea, but now the hard work began. We only had six minutes to convince Evelyn that our idea was worth producing into an entire documentary. The thought of what the video could turn into sent a tingle up my spine. Was this what real reporters felt like when they started digging into a story?

"I'll do a storyboard so we know what scenes we want to include. I have templates from Mr. Clovis," Scout offered.

At Scout's mention of his visual studies teacher, I realized he hadn't said anything about his photography portfolio, the one I thought he'd do well on. With other friends, I might have shied away from bringing it up, but not with Scout. We told each other everything. "How'd you do on your photography assignment?" I asked.

"Um...he liked it. We didn't get marks or anything, just comments."

I didn't need to be a budding investigative journalist to catch the flicker of hesitation. "What were the comments?"

A tiny smile pulled at the corners of his mouth. "That my photos were captivating and told powerful stories. He said I was an emerging talent."

I blinked at Scout. "Seriously?"

Scout shrugged it off, like being called an emerging talent wasn't a big deal. I didn't know why he'd kept the news to himself. For a second, I wondered if there was more to the story than he was telling me. But, no, Scout and I had been friends forever. There was nothing we couldn't say to each other. It was probably because deep down he didn't believe in his talent the way Mr. Clovis—and I—did.

CHAPTER 4

The halls at school were buzzing with before-class chatter. I tried to tune everyone out and concentrate on Scout's next question. I had a science test second period, and Scout was quizzing me. "Cell membrane?" I guessed.

"Correct!" He was about to flip to the next cue card when Mr. Clovis appeared. He was hands-down the best-dressed teacher at TSMS. Today, his white sneakers looked crisp against his dark jeans.

"Hey, Scout," he called from across the hall. "Got an answer for me?"

I tilted my head. *Answer for what?*

"Um, not yet," Scout replied. His eyes darted in my direction, then down to the floor.

"I'll wait. Just so long as you give me the *right* answer," Mr. Clovis said with a laugh.

"Okay, yeah," Scout tried to laugh too, but it sounded more like he was choking.

"What was that all about?" I asked. I'd had Mr. Clovis for photography and film in sixth grade but had quickly realized I was meant to be in front of the camera and not behind it. I'd opted for drama this year instead.

"Just a photography thing."

"What kind of photography thing?"

"Um, a camp he told me about. It's not a big deal." He tried to shrug it off, but I saw the look on his face. There *was* something he wasn't telling me.

He picked another cue card from the pile. "Next question," he said, conveniently changing the subject.

I wondered if the mysterious photography camp had anything to do with Scout's photography portfolio. He had been sketchy about both things, but I pushed them to the back of my mind. All my energy needed to be focused on the Veracity video, which was what Scout and I were discussing later that day as we walked Miguel's dog, Hank. Scout and I exercised him when Miguel worked late.

It was impossible to have a bad day around Hank. He greeted everyone like they were his favorite person,

not just by wagging his tail, but by shaking his whole back end. All I needed to do was run my hands over Hank's velvety, brown ears and my mood lifted.

"I asked Grandma about the photos," I told Scout as Hank sniffed a tree beside the sidewalk outside Umbrella House. "She said it was okay to look through them. I'll do that tonight. Besides the first squatters, who else should we interview?"

Scout considered the question. He thought of our videos in terms of the visuals. "What about kids at school? It's supposed to be young voices, right? Maybe we could ask our friends their opinions about how the neighborhood is changing. We could film here, in front of Laugh Emporium." The amount of graffiti was growing by the day. Besides all the messages, there was something else new. A big yellow sign in the window read, Store Closing. Everything Must Go!

Since you can take your dog almost anywhere in New York, and Hank knew how to behave in stores, Scout and I decided to pay Mr. Kricklewitz a visit. "It's so busy," Scout said as we navigated our way through the aisles.

At first I thought the customers were here because of the sale, but then I overheard a few people talking. "I used to come here with my dad, rest his soul. He and Mr. K went way back."

"My first job was working at this store. I hold the record for most fake barf sold in a single day."

"I can't believe it's closing. Mr. Kricklewitz donates prizes to my kid's school every year."

Scout elbowed me. "Isn't that—" he nodded toward two guys who were asking Mr. K for a photo. One was a comedian I recognized from TikTok. "This place is a gem," he announced and smiled as they posed for a selfie.

With all the love in the store, no wonder Mr. Kricklewitiz's eyes were wet. "I'm not ready to call it quits," he told the comedian, "but..." he held up his hands in a helpless gesture. I thought about what we'd talked about at the tenants' meeting and wondered how many more businesses were going to close because their leases weren't renewed, or the rent got too expensive. People who lived in high-end condos didn't want to buy used vinyl or get their hair cut *and* do laundry at Rocky's Barber Shop and Laundromat... or buy groceries at a small store like Li's Market, or tacos from the take-out window at Big Mamma's. Lenny was right when he said the character of the neighborhood was changing, and that we couldn't sit back and let it happen.

We left Laugh Emporium without saying anything to Mr. K. He was swamped with other well-wishers

anyway. After passing Hank's leash to me, Scout got out his phone and snapped a photo of the window with the yellow Store Closing sign in the window.

We weren't just losing a store. We were losing a piece, an important piece, of the East Village.

Chapter 5

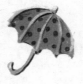

When I got home from our walk, the apartment was empty. Grandma had left a note reminding me where she'd gone.

Went for dinner with Ulli and Syd. Leftovers in fridge.
Love you! Xo

With the apartment to myself, I decided to look through Grandma's photos. She stored them in an antique credenza that sat between the front windows. While the rest of the furniture at our place came and went, depending on what she could sell at the flea market, the credenza was huge, so it stayed where it was.

I opened the drawer and pulled out the box

of photos. These were all from the days when phones didn't come with cameras. Most of the pictures had a date on the back, but they weren't in any order. I sifted through them. There were *tons!* Since visuals were Scout's job, I decided to take the whole box to him. I checked to make sure I had everything and spotted a file folder at the back of the drawer. Inside were newspaper articles—perfect for research!

The first headline caught my attention. It was from a *New York Times* article from 2002: "Midnight Muralist or Village Vandal: East Village Mural Appears to Cheers and Jeers." The photo beside the article showed a mural of a Converse running shoe stomping a bag of money.

Dubbed the Midnight Muralist by some and the Village Vandal by others, the graffiti artist's latest piece was discovered this morning, signed with a trademark crescent moon. Reaction from local residents was overwhelmingly positive. Not so from the mayor, who repeated that private property is no place for graffiti.

This was exactly the kind of information I needed. If we were going to do a video about our neighborhood, we needed to include something on the

Midnight Muralist. I continued skimming the article, and a little farther down a familiar name caught my eye.

Musician Leonard Rizzoli has been living in the East Village since the late 1980s. He doesn't see a problem with street art. "He's speaking for us, the people who live here, about things that matter," Rizzoli said. He went on to say that he'd sent many letters to the City Council complaining about housing and sanitation, all of which went ignored. "But they can't ignore a three-story mural!"

I grinned as I read Lenny's words. He hadn't changed much in twenty years.

There were lots of other articles about Umbrella House and how the squatters had gone to court and won the right to stay. There were also some about the forced evictions in May of 1995.

The next article I found had nothing to do with Umbrella House. The headline read, "East Village Community Art Show Winner." The photo below showed a boy with a mop of curly hair and a gap-toothed smile. My dad! Beside him was another familiar face— Miguel's. A painting sat on an easel with a First Place ribbon on it.

The caption under the photo said: *Sam Markowski celebrates with friend Miguel Santos after winning first place in the Under 18 category.*

Grandma said Scout and I reminded her of my dad and Miguel. As kids, they'd also been inseparable, but three times the trouble we were. Miguel was my go-to for stories about Dad. He'd never mentioned this art show, though. I tucked the article into my notebook, eager to ask Miguel about it the next chance I got.

"This one's great," Scout said, holding up a photo. It was one of the earliest photos in Grandma's collection. Lenny wore jean shorts, combat boots, and his leather vest. A cigarette dangled from his mouth as he balanced some two-by-fours on his shoulder. In the background, graffiti covered the walls and debris littered the floor. Living here back then hadn't been easy.

Everything I'd found in the credenza was strewn across Scout's desk. "There were all these articles too." I passed him the file folder. He paused sorting photos and flipped open the cover. The *New York Times* article about the Midnight Muralist was on top. "They quoted Lenny," I said and pointed to the paragraph.

"No way!" Scout took a closer look, reading quietly

under his breath. "I've always wondered why the Midnight Muralist stopped painting."

"There's an article about it somewhere in here." I searched and found the one titled "Council Sends Message to Graffiti Artists."

"The laws about vandalism got really strict," I explained. "It was automatic jail time if someone was found guilty."

The photo with the article was of the Midnight Muralist's last painting. Titled *Art Is Not a Crime*, it showed a group of riot police closing in on someone with a can of spray paint as if he was a terrorist, not an artist.

I pulled the article about my dad out of my notebook. "Look what else I found." It wasn't relevant to the video, but I wanted to show it to Scout anyway.

"Is that your dad and Miguel?" Scout asked. When I nodded, he grinned. "You look like him."

"You think?" I not-so-secretly liked to hear that, especially since I didn't know what my mom looked like. She and Dad had met in California. Their relationship lasted until she became pregnant and had me. She had tried, but she really wasn't ready to be a mom, so Dad returned to New York to raise me on his own.

"Did you know your dad liked to paint?" Scout asked, interrupting my thoughts.

I shook my head. I knew other things, though, little scraps that I'd collected, like how tall he'd been when he was my age, thanks to the pencil lines on the kitchen door frame. He'd liked spicy food, same as me. He'd also been a really good skateboarder. He and Miguel spent hours skateboarding at TF, the asphalt skatepark at Tompkins Square Park. I held all these details close to my heart.

They weren't much, but they were something.

CHAPTER 6

I didn't have a chance to ask Miguel about the article until I knocked on his door a few days later. Inside, I heard Hank cross the hardwood floor, excited as always to see who it was. He was going to be disappointed when he realized I was there to talk to Miguel, not take him for a walk. I could have gotten the full story from Grandma, but I'd wanted to hear it from Miguel. It was hard to explain, but listening to him talk about my dad made me feel a little closer to him. Miguel knew things Grandma didn't.

"Hey, Roxy." Miguel's dark hair was pulled into a ponytail at the base of his neck. He didn't bother to hold Hank back and, in seconds, Hank was showering me with doggie love. He galloped back inside and stood under the hook that held his leash.

"Sorry, Hank. Not today," I said.

Miguel laughed and patted him. "We just got back from a walk. You'd think I never took him out!"

I entered Miguel's apartment and gave Hank one more scratch under the collar. "I was going through some of Grandma's things, and I found something I wanted to show you."

Miguel motioned toward the living room, if you could call it that. The previous tenant had kept things basic, and all of Miguel's energy went into his store, so the apartment still had a squatter vibe to it. The kitchen consisted of a hot plate, a bar fridge, and a toaster oven. Along one wall in the living room, shelves sagged under the weight of Miguel's many books.

He pulled over a kitchen chair for me and sat on the couch across from me, putting his feet up on the coffee table between us. As usual, he was wearing Converse runners, a hold over from his youth—all of it misspent with my dad, according to Miguel. Hank joined him, sprawling across most of it. I pulled the article out of my notebook and passed it to him.

Miguel snorted softly, shaking his head at the photo. I loved moments like this. Learning about some secret memory the two of them had shared. The same thing had happened when I'd dug up a cassette tape of Umbrella House Boyz, their truly horrible rap group.

It had been jammed between the wall and the base-board behind my bed. Miguel said they started it in eighth grade to impress a girl my dad liked. Grandma found a cassette player at the flea market and brought it home so we could listen to it. It was the first time I'd ever heard my dad's voice. I played it so much I wore out the tape, but not before Scout cleverly recorded it on his computer as a sound file.

"Oh, geez," Miguel muttered under his breath. "The art show. I forgot all about that." He smiled, and when he looked at me, his eyes were soft. Grandma called them his "syrup" eyes, because they were the same color and just as hard to resist. She said those eyes got him and my father out of a lot of trouble as kids.

"I didn't know Dad was a good artist."

"Yeah, he was. He loved to draw. For a while, he never went anywhere without his sketchbook. Kind of like you with that notebook." He nodded at what I held in my hand. "You know, his sketchbooks are prob-ably kicking around the apartment somewhere. Your grandma never throws things away. You should try and find them. See for yourself how talented he was."

My heart lifted at the idea of leafing through my dad's drawings. Miguel was right, Grandma was super sentimental. Every piece of art, every school award, and every card I'd ever given to her was in a box

marked Roxy. It was stored in the front closet with our coats and winter boots. There probably was a box of my dad's stuff somewhere. I just had to find it.

The creaky wooden floors woke me up the next morning as Grandma got ready to leave. It was six o'clock, and my room was still dark. Sometimes I went to the flea market with her. I liked chatting with customers and wandering through the stalls. But Scout and I had made plans to work on the Veracity video this afternoon, so she was on her own.

I waited until I heard the deadbolt lock click into place and Grandma's footsteps recede. There was another reason I hadn't wanted to go with her. I'd been thinking about my dad's sketchbook.

Kicking the covers off my legs, I got out of bed.

I could have asked Grandma about the sketchbook last night, but something had stopped me. Selfishly, I wanted a piece of Dad to myself. All my memories of him had been filtered through Grandma or Miguel; finding his sketchbook would give me something that was directly from him and just mine.

I started my search in the front hall closet. Grandma called it the Black Hole because things went

in there and never came out. A chain dangled from the ceiling lightbulb. Even with the light turned on, the closet was crammed with so much stuff that seeing anything was difficult.

Out came the vacuum, a step ladder, the never-used ironing board, a fake Christmas tree, a tool kit, all our coats and jackets, and the bin of mittens, scarves, and knit hats. Finally, I got to the stack of boxes. The one on top was marked Taxes and under that was an Important Documents box.

But there was nothing marked Sam. I stood in the closet, thinking. *Where else would she have stored his stuff? The storage locker she uses for the flea market?* If that was true, my secret search was over, because I'd need Grandma's key and her code. We didn't have storage anywhere else in the building. The basement just had the laundry, the garbage and recycling bins— and cockroaches.

I scanned the apartment. I knew what was in every kitchen cupboard. Grandma's room had a small wardrobe crammed with clothes. My eyes landed on the credenza. In addition to the bank of drawers where Grandma kept photographs, there were two side cupboards large enough to hold a box of mementos.

It was worth a shot. The cupboard on the left had business files, a shoebox of receipts, and a couple of

jigsaw puzzles. Before I went to the cupboard on the right, I balled my hands into fists and wished as hard as I could that something would turn up. The hinge on the door squeaked as I opened it. Inside were sewing supplies and a container filled with buttons. Behind that was a cardboard box. My breath caught. "Please," I whispered. "Please let it be his." I dragged it out. Sam was written in Sharpie marker across the top.

"Yes!" I lifted the flaps and looked inside. Just as I'd suspected, there was a collection of schoolwork, report cards, elementary school crafts, and the First Place ribbon from the art show. I pulled it out and stroked its satiny smoothness. But no sketchbook.

I sat back on my heels, disappointed. It would be fun to go back through all of this, but I'd had my heart set on the sketchbook and what I could discover in it. I glanced in the cupboard and saw that it wasn't empty. Something had been behind the box. I tried not to get my hopes up, but the thing sitting on the shelf was sketchbook-shaped....

I reached in, and as my fingers closed around it, I knew I'd found what I was looking for.

The cover was black and pebbled, the edges soft and worn. This Book Belongs To was stamped on the first page, and where I expected it to read Sam Markowski, there was a different name. Miguel Alvarez Santos.

I paused, confused, then reasoned that Miguel might have given it to my dad. Scout and I shared things, often forgetting which one of us was the original owner. The hoodie I was wearing right now belonged to Scout.

I turned to the next page, and the next, my astonishment growing with each new sketch. The drawings weren't just good—they were incredible. Some were portraits of people I knew, like younger versions of Mr. Kricklewitz and Lenny. Others were still life drawings. An apple that looked so real I sniffed the air, sure I could smell it. Was my dad really this talented? The sketch was dated and had a tiny *S* in the corner.

On the next page was a familiar image. It was a drawing of the flowering vine painted by the Midnight Muralist titled *Concrete Jungle*.

In real life, the mural was on the side of a narrow two-story building. A vine grew out of a crack in the cement. As it trailed up the wall, it sprouted into an explosion of flowers and greenery. Tendrils of the vine spelled out the title, and the Midnight Muralist's trademark moon signature was at the bottom.

My dad must have been a fan. A *big* fan, because there were more sketches after the first one. Details of the leaves and flowers, like he was trying to copy

them exactly. There was a list of titles with *Concrete Jungle* circled.

A few pages later were drawings of familiar shoes. Converse runners—the low-top ones Miguel and my dad had worn. He'd drawn them from all different angles, and then on the next page—I laughed out loud. It was another sketch of a Midnight Muralist piece. The one of a shoe stomping a bag of money.

This sketch was also dated 2001. I was about to go to the next page when I paused. 2001? That didn't make sense. In the article I'd found, it said the mural had been revealed in 2002. How could Dad have drawn the mural before it was even painted?

Maybe...he'd dated the sketch incorrectly? I flipped back to the beginning of the sketchbook, pausing at the sketch of the apple. The apple...the Midnight Muralist had painted an apple.... It stretched across two sides of a corner building at E. 3rd and First Ave. On the West side the apple dripped in gold and on the south side of the building, the same apple was rotting. The mural was called *The (Real) Big Apple*. Was a sketch of that mural in here too?

I forced myself to thumb through each page slowly so I wouldn't miss anything. A tingle ran up my spine when I found it. It was just like the mural. I saw the date on the sketch but didn't know if it had

been done before or after the mural had been revealed. Then, right at the end was a page that proved whoever had used this book was the Midnight Muralist.

I grabbed my notebook and the laptop. Getting to the bottom of this was going to require all my research skills. I cracked my knuckles as I waited for the computer to warm up. Then I got to work.

CHAPTER 7

Using the Midnight Muralist Wikipedia page, I made a timeline that included the date, location, and title of each mural. I did what Evelyn Pauls recommended and looked at the evidence objectively. Besides the sketchbook, what else made my dad a likely candidate?

He had the motive. He lived in the East Village and understood the struggles of the neighborhood. But... did he have opportunity? The murals always appeared in the morning, leading people to believe they'd been painted overnight. No one knew how he'd pulled it off, but there were theories. In a city like New York, buildings were always under construction. It wouldn't have raised any eyebrows if the Midnight Muralist had put up a scrim, one of those semi-transparent screens, in front of a scaffold and worked on the piece for weeks.

Or, the Midnight Muralist wasn't one person, but a team of people who worked together to complete the mural in one night.

My mind clicked through possibilities. What if Miguel *and* my dad had done the murals? It would have been easy to sneak out if their parents thought they were sleeping at each other's apartment. That actually made sense! My dad and Miguel worked together. *They* were the Midnight Muralist!

"Roxy?" I jumped at the sound of Scout's voice. He was knocking on the door. I'd forgotten about our plans to work on the Veracity video.

"Hang on," I called, stepping over boxes and jackets. I unlocked the door and opened it. I was breathless with anticipation and couldn't wait to tell him about the sketchbook and everything else I'd discovered.

"I have something to tell you," we said at the same time.

"You first," we both said.

"Jinx!" Scout said immediately. "You owe me a soda." I rolled my eyes at our childhood joke. His smile disappeared as he took in the mess in the apartment and my pajamas. I was usually showered and dressed by now.

"What's going on?" he asked.

"You better sit down," I said and pointed at the couch. He wound his way around the boxes and piles of

jackets and flopped down in his usual spot, putting his feet on the patterned ottoman in front. I grabbed my laptop and notebook and joined him.

I tapped the keyboard to bring the screen to life. In front of Scout was the timeline I'd created. "Is this for our video?"

I couldn't stop a grin from spreading across my face. "Sort of." I told him about my conversation with Miguel, and that my dad had been a talented artist. "Miguel said I should look for his sketchbook, so I did, and I found it." I held out the sketchbook. "Take a look."

Scout opened it. "It says Miguel Alvarez Santos."

"I know, but it was in the credenza, stuffed behind a box of Sam's stuff. When you see what he drew..."

Scout's mouth hung open as he went from one page to the next. He paused at the *Concrete Jungle* drawing. I held my breath waiting for him to come to the same conclusion as I had. The next page was the list of titles and then, the Converse runners. "Look at the date," I pointed to the sketch. "Now, look at when it was revealed." Scout glanced to the timeline on my computer.

"Whaaaa?"

I nodded, biting my lip to stop from screaming. "Right?!" All the excitement that had built up was going to explode out of me. "And here's the clincher." I turned

to the last page and showed him all the drawings of the Midnight Muralist's signature crescent moon. "He was practicing!"

"No way!" he stood up, letting the sketchbook fall to the couch. His hands tangled in his hair as he walked in a circle, trying to make sense of the inescapable truth. "Do you know what this means?"

I did. I most certainly did. "Can you believe it?"

Scout flopped back down to the couch, shaking his head in disbelief. "This is big. Like..." he mimed his mind exploding.

It wasn't just the revelation about the Midnight Muralist's identity, either. I had accidently uncovered the scoop of the decade. "I think it was both of them, my dad *and* Miguel who worked on the murals."

Scout nodded. "Yeah, that makes sense."

Then I told him what I'd been thinking about since I put it all together. "I think we need to switch gears for the Veracity video."

Scout held up his hands putting on the brakes. "Whoa! You want people to know? Miguel and your dad kept what they were doing a secret for a reason. The police might come after Miguel. I mean, they were breaking the law. Those tougher punishments for people caught vandalizing, remember?"

Honestly, I hadn't thought about that. The murals

had been painted so long ago. Would the police still care? The murals had become iconic East Village art. They were as much a part of the neighborhood's history as any famous landmark.

"We could do one of those interviews where we change the person's voice and put them in shadow, or like, pixelate their face. We don't have to reveal Miguel's identity unless he wants us to." I gave Scout one of my super-intense looks. "If we show that our neighborhood is dealing with the same problems now as it was then, we could win the contest."

Scout wasn't convinced. "I don't know. If Miguel wanted his secret out in the open, he'd have told it already."

"Or not. Maybe he wants to but doesn't know how." Miguel was low-keyed. I couldn't imagine him seeking out the spotlight. "We could help. Give him a nudge."

The way Scout stared at me, I knew I had pushed it too far. "Roxy, seriously. You can't out Miguel unless he wants you to. It's not fair."

"What if he says it's okay? That he's ready for people to know the truth? We could show him what I found and ask him about it. See what he says."

Scout paused, thinking it over. "Okay, but if he says to drop it—"

"We drop it," I agreed, and jumped off the couch.

It wasn't until we were cleaning up the closet vomit that I realized Scout had never told me his big news. "Didn't you want to tell me something?" I asked.

"Oh. Um...no. It's not important."

With visions of a Veracity exclusive in my eyes, I skipped off to get changed, anxious to get the real story from Miguel.

CHAPTER 8

"You ready?" I asked Scout. We were standing in front of Miguel's door. I was bubbling with excitement. Scout looked like he was about to get a cavity filled.

I took a breath and pushed my shoulders back. "Remember," I said, as I raised my hand to knock on the door, "we found the sketchbook, realized it was his, and are doing the neighborly thing by returning it."

Scout snorted. "Yeah, we're being super *neighborly*."

I brushed his concerns away. Evelyn said getting to the truth is a messy journey. Did her stomach turn into a bundle of nerves when she confronted someone? Mine had, and Miguel was practically family! I crossed my fingers, hoping Miguel wouldn't deny everything. If he did, I'd promised Scout I'd let the story stay buried, but as if! I'd find a way to tell it. My dad was the Midnight

Muralist! Or part of the team that was the Midnight Muralist. His legacy was mine too!

On the other side of the door, Hank barked. There was a moment of shuffling and Miguel shushing Hank, then the door opened. As soon as Hank realized it was us, he came into the hall to greet us. Scout hugged him around the neck and whispered something in his ear. I wasn't positive, but it may have been "Roxy made me do this."

Miguel took in my serious expression, notebook, and pen. "Am I in trouble?" he asked, grinning when he said it.

I laughed, to put him at ease. I was sure Evelyn would have approved of that. She always tried to make her interview subjects feel like she was on their side. It wasn't an interrogation; it was an opportunity to tell the truth. "Mind if we come in for a minute?"

When Hank realized that, once again, I wasn't here to take him for a walk, he lay down at the door and sighed.

I'd practiced what I wanted to say while I was in the shower, but now that we were sitting across from Miguel, the words stalled on my tongue. Scout looked uncomfortable and fiddled with a loose thread on his cut-offs. "I found my dad's sketchbook," I said. I gestured for Scout to pass the sketchbook to Miguel

and watched him carefully. There was no surprise or guilt on his face as he reached for it, just curiosity.

"At least, I think my dad did the art. Your name is on it," I added.

Miguel opened the cover to check but didn't look surprised. "Yeah, it was probably something I thought I needed for school and never used. Where'd you find it?"

"In the credenza."

Miguel's mouth tilted up in an absent smile as he turned to the first page. My pulse quickened. "Do you remember Dad drawing them?"

He shook his head slowly. "These don't look familiar," he said.

I leaned forward in my chair. The next page was the sketch of the study for *Concrete Jungle*. He only got a peek at it before he snapped the book shut and handed it to me. "Thanks for showing it to me."

"No problem," Scout said, standing up and eager to leave.

I curled my toes in frustration. I wasn't going anywhere until I had some answers. Ignoring Scout, I said, "I noticed something kind of weird." Scout groaned and sat down again. "A lot of the drawings remind me of the Midnight Muralist's art. Don't you think so?" I opened the sketchbook to the drawing of the shoe stomping on the bag of money.

Miguel met my eyes, but his face stayed carefully blank. Too blank. I kept pressing. Scout had warned me about going too far, but the truth was so close, I could taste it. "What's weird is the mural didn't show up until six months after the date on the sketch."

There was a long silence. "What are you asking, Roxy?" Beside me, Scout coughed out a warning.

"I have a theory," I said.

"Oh, boy," Scout ran a hand through his hair.

"The sketches were drawn by my dad in *your* book. He was practicing for the murals that you and he would paint. You and Dad were the Midnight Muralist!" I crowed the last words triumphantly. The nerves I'd felt when I knocked on Miguel's door were gone. They'd been replaced with a warm glow of satisfaction. My first real investigation, and I'd nailed it!

I expected Miguel to shake his head in amazement at my investigative skills. Instead, he chuckled. "That's your theory? That Sam and I were the masterminds behind the murals? Us? Two teenagers?"

"Yes," I said, but it came out more as a question. "Your name is in the sketchbook. You said my dad had talent....You guys were always doing stuff like that." The pieces all fit. They were even signed *S* for Sam...or maybe Santos, Miguel's last name.

"Your dad was talented," he said. "But the murals

are next level. There was no way we could have pulled them off." He looked at me with pity. "I'm sorry, Roxy, but I swear, we didn't paint them. We weren't the Midnight Muralist."

I stared at him, wishing what he'd said didn't make sense. I'd been so sure about my theory, but now I saw that I'd been hoping for too much. There was no legacy for me to uncover, no incredible talent lurking in my family.

Even worse, our Veracity video wasn't a sure winner.

"But if you didn't do them, then who did?" I asked. "Why was this sketchbook in Grandma's credenza?" I watched Miguel carefully. Evelyn Pauls said you could learn a lot about an interview subject by their body language.

Miguel's was screaming that he knew more. He tucked a loose strand of hair behind his ear and licked his lips nervously. "No idea." His eyes slid to the sketchbook on my lap.

I must have missed something. I leafed through it, not sure what I was looking for.

"Roxy!" Scout gasped when I flipped to the last page. "The moon!"

"What about it?"

"The moon wasn't about *when* the murals were painted, it was about *who* painted them!"

My stomach lurched as I understood Scout's meaning. The Midnight Muralist wasn't Miguel or my dad.

It was my grandma!

CHAPTER 9

"Selena is the Midnight Muralist!" Scout practically shouted.

I looked at the crescent moon drawings on the page in front of me. The name made sense. So did the *S* on the sketches, but Grandma wasn't a vigilante. She didn't even paint, unless it was one of her refurbished flea market pieces. How could she be the East Village's legendary graffiti artist?

I stared at Miguel in disbelief. "It can't be Grandma," I whispered.

"Why not?" Scout asked.

"Because...she's...she's *Grandma!* She's not like that."

A flicker of amusement flashed through Miguel's eyes. "Like what?"

I fumbled for the right word. "A *rebel*." All my life, Grandma had worked hard. I couldn't imagine her as a risk-taking rule breaker. And then, there were her art skills. "I don't even know if she can draw."

"You know why she moved to New York, right?" Miguel asked.

I nodded. She'd told me lots of times. "To go to NYU." She'd moved here from upstate, but then dropped out when my dad was born. Unfortunately, she never went back to finish her degree.

Miguel nodded. "She was in the Faculty of Fine Arts. Your grandmother wanted to be an artist. That's how she met Ortiz. They went to school together. When Sam and I were kids, she painted all the time."

I held the book on my lap, running my fingers over the cover. "Why did she stop? I don't mean the murals. I know the laws got stricter," I rushed to add. "But art in general. She was such a talented artist."

Miguel held his hands up, at a loss for an answer.

"Do other people know she's the Midnight Muralist?" Scout asked.

"Just me. Sam knew too, of course." Miguel met my eyes. "I always wondered if you'd figure it out."

Had I figured it out? Scout had been the one to put the clues together. All I'd done was find the sketchbook.

"I can't believe she kept it a secret all these years."

Scout shook his head. "Everyone loves the murals. She could have been famous...or rich. Like that Banksy guy. He's a famous street artist, and his work sells for millions!"

Millions? I tried to imagine Grandma and me living in a fancy apartment in a different neighborhood, but I couldn't do it. We were way too East Village.

"She didn't paint them to get rich," Miguel said. "They were to send a message. To speak up for the East Village."

I leafed through the sketchbook, thinking. Now that I knew Grandma was the Midnight Muralist, I couldn't pretend I didn't. Miguel and Scout's voices blurred into the background as I imagined confronting Grandma with the sketchbook.

If I were a real investigative reporter like Evelyn Pauls, I'd have a duty to tell the world what I'd uncovered. I'd been ready to do it when I thought it was my dad and Miguel. But I couldn't expose Grandma. What if Scout was right about the police still wanting to catch the muralist after all this time?

I'd never been faced with a dilemma like this before, and it made me wonder if I had what it took to be a hard-nosed investigative journalist. Getting to the truth of a story was important, but not if it hurt someone I cared about.

CHAPTER 10

After Scout and I left Miguel's, I went back to my apartment to figure out what I was going to say to Grandma. I'd gone from pacing the living room to drumming my fingers on the kitchen table as I waited for her. Part of me wanted to jump up and down with excitement when she got home, singing, "You're the Midnight Muralist!" like we'd just won the lottery.

But another part of me knew what I'd discovered was serious, and she'd kept it to herself for a good reason. Scout had nodded understandingly when I told him I wanted to talk to her by myself. Even though the murals were public and on display for everyone to see, getting to the truth was personal.

It was a secret only a few people had known. One of them had been my dad. And now, I knew.

And it was going to stay that way. As delicious a scoop as it was, there was no way I could share Grandma's identity with the world.

I'd tried writing out the questions I wanted to ask—I had so many—but my mind was too jumbled. When I thought about Grandma objectively, the way a reporter should, I pictured a woman about to turn sixty with thick, wavy hair shot through with strands of gray. Her face lined by love and hurt, but always ready with a smile. Her brown eyes were sharp and determined. She was fair and honest but would haggle for half an hour at the flea market if it meant an extra five bucks for her family. It seemed impossible that she was also the Midnight Muralist, an East Village hero.

I was about to start pacing again when I heard Grandma in the stairwell. She was talking to Lenny. His gravelly voice carried like no one else's. Even though I knew she was coming, I jumped when the deadbolt clicked open, and she walked in.

I let out a breath. "Hi, Grandma." I tried my best to sound like I always did. She hung her purse on the hook behind the door and kicked off her shoes with a sigh. On her way past, she dropped a light kiss on my cheek. Being around old furniture at the flea market gave her a musty, cedary odor. The familiar scent reminded me that whatever I'd found out today, she was still Grandma.

"How was your day?" she asked.

"Um...eye-opening?" I tried. *Understatement of the century.*

"Oh?"

"I found something in the credenza. Something amazing." She turned my way, and I held up the sketchbook. "It was hidden behind a box." A flicker of surprise crossed her face. "It has Miguel's name in it, but the art isn't his."

"Whose is it?"

"The Midnight Muralist's." I risked a glance in her direction. Grandma stood frozen, waiting to see what I'd say next.

"The sketches are dated. I made a timeline and cross-referenced them with the murals. Some were completed months before the mural was revealed. It was Scout who made the connection about the crescent moon. From there, everything else made sense." I grinned. I couldn't help it now that the secret was out. "These are your sketches, aren't they? You're the Midnight Muralist!" It was the second time today I'd said those words, but this time, I was confident that I was right. "Grandma, you're like, a superhero!"

She clasped her hands together, fidgeting with the bracelet on her wrist. The bracelet I'd given her with moons that symbolized her name. *How did I miss that?*

"A superhero?" she laughed under her breath. "Hardly."

"I can't believe it. That you were an artist, and you used to paint and..." I drifted off, trying to find the right words for all the things I wanted to say.

Grandma sighed. "It was such a long time ago."

She pulled out the chair she'd been standing beside and sat down. "Can I see it?" she asked and reached for the sketchbook. "I forgot all about this." She brushed her hands across the cover like it was an old friend.

I wanted to know everything: how she started, why she stopped, and how she managed to keep what she was doing a secret. As if reading my mind, she said, "Go ahead. I know you have questions."

I exhaled wondering where to begin. "Was *Concrete Jungle* your first mural?"

"No. It was the first one I signed." As Grandma spoke, she got a wistful look on her face. "I finished the design months before I worked up the courage to paint it. I doubted myself the whole time. But when it was done, and I stood back to look at it...it was like fireworks!" Her face lit up. "I couldn't believe what I'd created. And then over the next few days, seeing people's reactions and the joy they got from my art, I got hooked on that feeling. All I could think about was what my next piece would be."

"How did you keep it a secret?" That seemed like the most impossible part.

"It wasn't easy." She rolled her eyes in exasperation. "Back then, I had a night job cleaning offices at a building in Midtown. It was only once a week, so when I was working on a mural, I said someone was out sick, and I'd picked up their shifts. Ortiz was the only one who got suspicious. He figured with the hours I was working I would have had more money." She laughed. "I did the math, and he was right! I told him I was sending money to my sister because she needed an operation."

"Grandma!" I exclaimed with fake horror. "You lied to Ortiz!"

She buried her face in her hands, laughing. "I know! I felt terrible!"

"What about while you were painting? How did no one see you?" Millions of New Yorkers had probably wondered the same thing. It struck me again that I was one of the few who would find out.

"I used a scrim, one of the screens construction companies use. They were all over the place. No one questioned one more. I forged permits to make it look official. Anyone walking past thought it was just another stalled construction project."

I shook my head at how much effort had gone into each mural—not just painting, but concealing them too.

"Sam figured it out after my fifth mural. He didn't believe I was working so many nights. He said he could smell the paint on me. The fumes clung to my hair. He and Miguel had a stake-out."

"Seriously?"

Grandma nodded. "But once they knew, Sam got scared. I couldn't blame him. The laws had changed. Even if I didn't think my murals were graffiti, the City Council and police did. If I'd been caught, I would have gone to jail. I was a single mother. Sam's dad was long-gone. It was too big a risk. As much as I loved painting, I loved Sam more. So, I stopped."

I sat back in my chair, digesting the information. "I won't tell anyone," I said. "In case you're worried. Neither will Scout."

She reached her hand across the table, so it covered mine. "I remember having this same conversation with your dad and Miguel. Making them swear they'd keep my secret. I think I threatened to take away the PlayStation if they didn't."

I smiled at the memory. Dad and Miguel were probably as shocked as Scout and I were. "I understand why you stopped painting the murals, but you could have kept sketching and painting."

"I did for a while." Grandma looked around the apartment, her eyes lingering at a spot by the window where

an easel may have once stood. "But things changed. The flea market got busier, and when you came along..."

I was the reason she stopped making art. I tried to draw back my hands, but Grandma held them tighter. "You gave me a purpose again. You filled me up the way art used to. If it was between painting or spending time with you, I'd pick you every time."

I smiled but couldn't help wondering if that was the truth, or if Grandma had fooled herself into *thinking* it was the truth. I'd seen her sketches. How could she give up something she was so good at?

Eating dinner across from the Midnight Muralist was surreal. I kept glancing at Grandma and shaking my head.

She gave me a look. "You have to stop doing that," she said. "People will wonder."

"Is it that obvious?" I asked.

"Yes."

Scout had texted a few times, but I didn't reply until after I'd finished washing the dinner dishes. I asked him to meet me on the front steps of the building. With a secret like this, there was nowhere private enough to talk at Umbrella House. Walking would ensure no one overheard our conversation.

Scout was waiting when I got outside. Delivery bikes zipped in and out of traffic with plastic bags of food knotted onto their handlebars. The *blip-blip* of a police cruiser sounded a warning up the block. Dusk had fallen, and soon people would spill out of restaurants and bars onto the sidewalks. Loud Saturday-night energy would take hold of the streets. "So?" he asked as we started walking down Loisaida, "What happened?"

I started at the beginning and repeated everything Grandma had told me.

Scout exhaled, shaking his head. "All these years of walking past art by the Midnight Muralist and *she was living in our building!*" he whispered the last part extra quiet. "Imagine if she hadn't given it up. I wonder how many more you-know-whats there'd be."

I was quiet as I thought about that. Entire blocks would have been Midnight Muraled.

We arrived at *Paradise Found*, the mural that Scout and I had grown up thinking was Thor's hammer. We knew now that it was a sledgehammer opening the sealed door of a squat. A bright, new world was visible through the cracks. "I thought I knew everything about Grandma," I said. "Turns out *that* was wrong."

I traced the shape of the crescent moon on the mural. It made sense that she'd used that symbol for her alter ego. Not just because of her name, or when

she painted. A crescent was only one phase of the moon. The others were hidden in darkness. Just like Grandma had been.

CHAPTER 11

I woke up early on Sunday determined to make some progress on the Veracity video. Major revelation or not, we still had to get the video finished if we were going to enter the contest. Grandma tiptoed around the apartment trying to be quiet as she got ready to go to the flea market. She opened my door a crack to check on me before she left. Today I sat up and stretched, an invitation for her to enter.

"I didn't mean to wake you," she said, opening the door wider. "It's still early."

"I know," I yawned.

Grandma smoothed out the rumpled sheets and sat down on the bed. Her fingers went quickly to her lips and then to the photo of my dad. I'd been thinking about him last night as I fell asleep, enjoying

the idea that he and I shared a secret. I nestled my head against her.

"Are you mad that we figured it out?" I mumbled. My voice was thick with sleep.

She pulled me closer. "No, I should have told you myself. One day, I would have." She planted a kiss on my forehead and a warm glow spread to my toes. Midnight Muralist, Selena, Grandma—whoever she was, she was mine.

A few hours later, I rapped on Miguel's door. It was mid-morning, but he looked like he'd just rolled out of bed. "Too early? I can come back."

Miguel took a long slurp of his coffee before uttering a bleary-eyed, "Nah, I gotta get to the store soon anyway." Hank came to greet me, nosing his head against my leg and looking for attention.

"I just wanted to tell you that I got the whole story from Grandma," I said, patting Hank.

Miguel raised his mug to his lips and took another gulp of coffee. "She told you everything?" I nodded. He appraised me for a minute, then nodded for me to join him inside. "I want to show you something."

The wooden floors creaked as I followed him across

his apartment to the wall of books. The smell of fresh coffee filled the air. Miguel stopped at the bookshelf. From a stack at the bottom, he pulled out a black-spined, hardcover sketchbook, almost identical to the one I'd found in the credenza. Dots of paint splattered the cover. He put it in my hands. "This is Selena's."

I raised my eyes to meet his. *Another sketchbook?*

He ran a hand through his hair, tucking it behind his ears. "Your dad took it when we were kids. He gave it to me for safe keeping."

"Why?"

"He thought Selena wouldn't paint if she didn't have it."

"Didn't she wonder where it had gone?"

Miguel met my eyes. "I think she knew. But it's been so long…"

I opened it. The first few sketches were studies she'd done for *Art is Not a Crime*, her last mural. As I turned the pages, I saw what Miguel meant when he said there was more to the story.

"A sixth mural," I whispered. The design was complete and, unlike the sketches for the other murals, Grandma had colored it. It would have been a show-stopper. "Wow," I exhaled. It was like finding buried treasure.

Miguel nodded. "Magic, huh?" I stared at the

sketch until I'd drunk it all in, then I stared some more. Finally I held the book out to him, but he shook his head. "It's yours, not mine. I should have given it back to Selena a long time ago. I don't know why I didn't." He paused. "That's not true. I was hoping one day she'd be ready to paint again."

Grandma had been firm about that part of her life being over, but I didn't blame Miguel for hoping.

As soon as I got to my apartment, I texted Scout. It was Sunday morning, so he'd be having breakfast with his moms at their regular spot, but this couldn't wait. *Big news. How fast can you get here?*

Scout didn't bother knocking. He breezed in wearing shorts and flip-flops. As soon as he shut the door, I held up the sketch of the sixth mural. He stared at it and then noticed the small *S* in the corner. "Is that—"

"A sixth mural? Yes, it is!"

"No. Way. Where'd you find this?" I told him about my visit with Miguel as Scout studied the drawing. "This would have been her best one. Can you imagine seeing it on a building?" He held it at arm's length.

"Well, imagining is all we can do because she's never painting again." I sat down on the couch.

"What a waste," he said, coming to join me. "The art is already done. All she has to do is paint it."

I snorted. "Like that's so easy." Her murals had taken weeks of working under difficult conditions at night.

"If a new mural appeared, people would go bananas. It'd be like..." Scout broke off, trying to come up with something equally as cool. Turned out, there was nothing as cool.

"It would be amazing." I sighed, knowing Grandma would never go for it. There was no point in lamenting something that wasn't going to happen. "We should work on the video," I suggested, changing gears.

Scout's foot started to jiggle, which only happened when he was nervous. "Before we do, I have something to tell you."

"What?" I didn't like way his eyes darted around the apartment. He looked guilty. *Is he going to tell me he doesn't want to do the Veracity video?*

"Remember that photography camp Mr. Clovis wanted me to apply to?"

"The one you said wasn't a big deal?"

"Um, yeah. I think I'm going to send in an application."

"Oh!" I laughed. *Phew.* "Yeah, for sure. You should do it." He was still jiggling his foot. "There's more?" I guessed.

"Yeah. It's not exactly local."

"Ohhh-kay, what does that mean?"

"It's in Washington, DC. For six weeks." He rushed through the last few words so quickly I was sure I'd heard wrong. But then I looked at his face and I knew I hadn't.

"Washington?" *Six weeks?* "You'd be gone all summer." A sick feeling inched its way up my throat.

"Almost all summer. Maman is going to see if we can switch dates on the beach house."

The beach house! Going with Scout and his mothers to Sag Harbor was the best part of summer vacation. What if she couldn't switch the dates? I looked at Scout. His face was creased with a silent plea. He wanted me to be okay with it even though it meant I'd be on my own for almost the whole summer. Something else dawned on me. "The Veracity video," I said weakly. "What if we win?"

Scout winced. "I guess you'd have to go on your own."

On my own? I tried to swallow down the sick feeling, but it had crawled higher and was firmly lodged just behind the hangy-down thing at the back of my mouth.

"Maybe with all the other stuff going on...now isn't the right time. Maybe I could ask Mr. Clovis to go next year, instead."

What I wanted to say was, "Yes! Good idea!" What I *did* say was, "No. Mr. Clovis knows what he's talking about. If he thinks you should apply, then you should."

Scout bit his lip, not fully convinced. I knew, if I wanted to, I could persuade him not to go. I could take advantage of his lack of confidence. I'd remind him about how much fun we always had hanging out and that going to camp in Washington, DC would be scary. He wouldn't know anyone. Did he really want to spend a whole summer with strangers?

But instead, these words slipped out of my mouth: "If I were you, I'd do it."

"You would?"

"Absolutely. I'm so excited for you!" My acting skills must have really improved because, hearing my voice say it, I almost believed it myself. We sat on the couch, smiling like dummies, neither of us saying anything, but at the same time saying everything, because we never sat like this. "I should probably do some work on the video," I said.

"Yeah, good idea," Scout agreed. "Do you want to go to my place?"

"Um, I'll just work on it here, I think. Alone. It's research, so..."

"Oh." My words hung between us. Usually we worked side by side, even if it was on different things.

All of a sudden, the air in the apartment felt heavier. "I've got the artistic statement on my application to finish anyway," he said. "Do you want to meet later? Or..."

I gave a non-committal shrug. "Yeah, probably. I'll text you."

What is happening? I never acted distant like this, but he'd never told me he'd be gone all summer before, either. We'd suddenly turned into strangers making polite conversation.

Scout got to the door and turned back. "We're okay though, right? Like, about the camp and stuff?"

"Uh-huh," I lied. "I just have a lot to do."

He looked like he wanted to say something else, then thought better of it. When the door closed after him, the sound echoed through the apartment. Scout and I didn't fight. Ever. We barely argued. This hadn't been a fight, exactly. No yelling, or storming away. Technically, it wasn't even a disagreement. So why, as I stared at the spot where my best friend had been sitting, were my eyes prickling with tears?

Chapter 12

July 4th.
Umbrella House Block Party.
Movie Nights at Bryant Park.
Ninth St. Block Party.
Grandma's birthday.
My birthday!!!!

The list of things Scout would be missing if he went to the photography camp kept growing. I knew other kids who went to camp all summer, but it was usually at a lake somewhere and they came back with suntans and embroidery floss friendship bracelets. Scout and I had never done that. Partly because Grandma couldn't afford it, but also because summer in the city was fun. There was always something to do. Every year we

made a bucket list of things and checked off as many as we could.

Last summer we went kayaking on the Hudson River with Monique, rode cable cars to Roosevelt Island for a picnic with Grandma, and tagged along with Amanda when she went to an artist's home in the Hamptons. We'd played tag on a lawn as big as a golf course. Who was I going to do all that stuff with if Scout was in Washington, DC?

The vision I'd had for summer was quickly being ripped away from me. If Scout got into the camp and we won the Veracity contest, I'd be working on the documentary without him. If we didn't win, I'd just... be alone.

The ache that had started in my chest when he told me about the camp grew. It *was* an amazing opportunity and one part of me wanted him to apply. But another, bigger part...didn't.

I was still reeling from Scout's news when Grandma came home. "I went to that new *taqueria* Ulli told us about," she said, holding up the bag. Ulli always seemed to know the best restaurants. I could smell the warm tortillas and spices through the bag, but barely cracked a smile.

"What's wrong?" she asked, taking dishes from the cupboard.

"Scout's applying to a photography camp. It's all summer in Washington, DC." There was no point in hiding my disappointment.

Grandma's eyes widened. Like me, she was used to Scout being around all summer. "Good for Scout!"

I snorted. "I thought we were entering the Veracity contest as a team, but if we win, I'm on my own."

Grandma shot me a look. "Which you can handle."

I slumped in my chair. "Doesn't mean I want to."

"Hey," she said softly. "You can't be mad at Scout for wanting to do this."

"I'm not mad," I replied.

Grandma raised her eyebrows in disbelief as she passed me a plate. "I think this could be good for both of you. You already know who you are, but Scout's still figuring himself out. He can't stay in your shadow forever."

Shadow? "He's not in my shadow," I argued. "We're a team." It was true that I liked the spotlight, but without Scout behind the scenes, *EaVillKids* wouldn't exist. Scout was the rock I stood on to stand out.

Grandma tilted her head like she didn't agree. "It always seems like you're the one calling the shots. You're a leader, and that's not a bad thing. But I also think it's important for Scout to find his own passions, not just go along with yours."

I frowned. *Was* I holding Scout back from following his own dreams? The ache came back, stronger now. I'd taken it for granted that Scout would always be there for me.

I looked at the meal Grandma had put in front of me, but I wasn't hungry. If Scout left, I'd be working on my own, something I'd never had to do before. Doubts about my own talent swirled in my head. What if Scout was the magic ingredient that made our *EaVillKids* videos popular? What if, without him, I was just another kid in front of a camera?

That night as I fell asleep, I thought again about what Grandma had said. As scary as it was, maybe it *was* time for Scout and me to try things on our own.

I hadn't texted him to work on the video like I said I would. Every time I picked up my phone to send him a message, Grandma's words stopped me. If Scout wanted to explore photography, who was I to get in his way? He had his artistic statement to finish. He couldn't do that if I bugged him about helping me with the video.

Working with Evelyn was *my* dream, and, with or without Scout, I had to try. The problem was that I only

knew how to do the on-camera stuff. Scout handled the filming, editing, collecting footage, music, and special effects. There wasn't time for me to learn. So, if we won the contest together, Evelyn would only be working with half a team making the documentary.

I could try to find a new partner, but the thought of working with someone other than Scout made me shudder. We practically read each other's minds when it came to *EaVillKids*. No one else had Scout's talent when it came to making videos anyway.

No, if I was going to do this, it had to be on my own. What was I good at? The answer was research and interviews. I also had Grandma's photos and the articles. An idea took shape in my head. I sat up, flicked on my bedside light, and grabbed my notebook.

Instead of a video recording, I could use audio-only for the interviews and put together a slide show of still images. It wouldn't look as polished as what Scout had planned, but with my voice-over narration, it would get the idea across.

Would it be good enough to make it into the top three? It might be a long shot, but I had to try.

My ideas filled two pages. Satisfied, I shut the book. Figuring out a plan put my mind at ease. I'd be able to sleep now. I rolled over to turn off my lamp. My dad looked out at me from the photograph. I liked

imagining him watching over me. A force guiding me and helping me when he could.

"Night," I whispered. I let the darkness swallow the words, and my worries, as I drifted off to sleep.

I woke up with newfound determination not to let Scout know how his news had affected me. I was going to forge ahead on my own and let Scout do the same... hopefully. My willpower almost dissolved when I saw the weather. There was nothing like a sky the color of concrete to sap newfound resolve.

"You have an umbrella?" Grandma asked as I hefted my backpack onto my shoulders. She'd given up on getting me to wear a rain jacket, or boots. I held it up to show her, wishing I could stay curled up in bed and not have to brave this drizzly day.

As usual, I didn't knock when I got to Scout's apartment. His door opened as I arrived, and we fell in step to the first-floor landing. I snuck a quick glance at him. Was there something different? A new confidence? It was understandable if he'd completed the application and sent it in. He was one step closer to the camp.

And one step farther from me, a little voice added.

"So? Get the artistic statement done?" I asked.

My umbrella flew open with a *fwip* when I stepped outside. The drizzle had become a downpour. Water gushed out of downspouts and flooded the sidewalk. Traffic whooshed through puddles, splashing anyone who was too close to the curb. Our shoes and the hems of our pants would be soaked when we got to school.

"Yeah, last night," he said. I thought he'd look more excited, but his expression was guarded.

"That's great," I said. But with the patter of the rain and the splash of traffic through puddles, my words were lost. For what felt like the first time ever, we walked to school without talking.

CHAPTER 13

"Scout Chang-Poulin, please report to Room 11. Scout Chang-Poulin, Room 11." The secretary's voice boomed over the PA system at the end of the day. It was loud enough to cut through all the chatter and locker slamming.

"That's Mr. Clovis's room," Scout said, glancing at me. "I wonder if he..." He let the rest of the sentence drift off. I stayed true to my resolve and didn't press him for details. I'd been equally as careful at lunch, talking about everything but the Veracity contest. If Scout decided not to go to camp, it wasn't going to be because of me.

Scout nodded when I asked if he wanted me to wait so we could walk home together. At least that was normal. "I'll be outside," I said. I made my way out

the back doors to the hardtop area and found a bench. The morning's rain had washed away the dirt and grime, leaving things shiny and fresh.

I'd thought putting my friend first would make the ache in my chest go away, but it was still there. Pretending that things were fine had made it worse. I scrolled through my social media feeds, looking up occasionally. The kids playing ball had left the court. They'd been replaced by two little kids on scooters. They were making a game of riding through the puddles like Scout and I used to do.

"Hey," Scout said softly. He'd arrived on silent cat feet, or maybe I'd just been too lost in thought to hear him.

I stood up, already dreading the unnaturally quiet walk home. Scout looked at me, waiting for the questions I'd usually ask, and when they didn't come, he frowned. There was an awkward silence. Our second one in as many days.

Scout hiked his bag up on his shoulder. We skirted puddles as we made our way across the hardtop. "Mr. Clovis gave me a camera."

"Oh, yeah?"

He reached into his bag and held it up. It was the kind with a lens sticking out, very professional looking. "He thought I should get some practice, you know,

in case..." His words drifted off. "But then I told him I hadn't applied yet."

I stopped walking and looked at him, surprised. "I thought it was due today?"

"It is."

"Why haven't you sent it in?" My heart should have been soaring at this news. This was what I wanted, but seeing the conflict play out across Scout's face made me feel anything but triumphant.

"Every time I tried to press send, I thought of what I was leaving behind and I couldn't do it. I've never done something like this on my own. What if, without you, I suck?"

"Scout." His name came out as half-groan, half-exasperated sigh. We rounded the chain-link fence and moved onto the sidewalk. "That's not possible," I assured him. I didn't even have to sugar coat the truth to make him feel better. "You've been doing camera work for *EaVillKids* for over two years, and you have a natural eye for photography. Mr. Clovis thinks you're ready. This is your chance. You have to take it."

"Yeah, that's what Mr. Clovis said too. He told me about the first time he left home. He was like eighteen and got invited to London, but when he got there everyone was super intimidating and he wanted to

leave after three days. He begged an instructor to drive him to the airport.

"She asked him if he really wanted to get better at his craft. Of course, he said yes. Then she said he could only get better if he pushed himself. Running back to where it was safe, where he wouldn't be challenged, or scared, wasn't going to make him a better photographer."

"So he stayed?" I guessed.

"No." Scout shook his head. "He came home, and he said he's regretted it every day since."

Oof.

"He said living with regret is way worse than being scared. Scared is short-term. Regret is forever." Scout shook his head. "And I know he's right, but I keep thinking about everything I'm leaving behind. It's scary," he said. The admission fell like a guillotine between us, slicing the tension.

"I know. I'm scared too."

Scout looked at me like I was joking. "You're never scared," he snorted.

"I am this time," I answered, my toe kicking a piece of glass toward a row of garbage bins. It bounced and pinged against the metal can.

"About what?"

Pretending things were fine was only making me

feel worse. I could lie to myself, but not to my best friend. "That you'll come back different, or you won't want to work on *EaVillKids* anymore. Maybe you'll find a new best friend." Scout opened his mouth to argue, but I kept going. "I've never done a video on my own. I have a plan, but...this is my chance to work with Evelyn and it might slip through my fingers."

His eyebrows knitted together in a frown. "Who said anything about you working alone?"

"Well, you've got the photography camp..." I drifted off. "I just assumed..."

Scout's shocked expression told me I'd been wrong. "It's your dream! I'm not going to bail on that."

"You're not?"

"No! I'll do whatever I can to make sure we win the contest. And after that..." He held up his hands. "We'll see what happens." The clouds from this morning parted, literally, and sunlight filtered down.

"So, we're both going to take a chance. Right?" I looked at Scout and waited for him to agree.

"Right."

I held up my pinkie finger. "Swear?" He linked his with mine. A lot of our promises had been sealed this way. The ache in my chest disappeared. I had my best friend back.

For the next few weeks anyway.

I refused to work on the Veracity video until Scout sent in the application. It was uploaded. One click was all it would take, but still his finger hovered over the button.

He'd shown me his artistic statement, and it wasn't what I expected. Instead of an essay, he'd created a photo collage. There was a digital image of Umbrella House for the backdrop. On top of it, he'd layered parts of other photos. One, a picture of a bird's nest, covered the fire escape landing outside of his apartment. His mothers and I were in it, watching as he took his first leap into the unknown. On the sidewalk below, another Scout filmed what was about to happen.

"It's about a kid who never flew on his own before," Scout explained. "I'm safe in my nest but deep down I know I can't stay there forever."

I smiled. "So, you spread your wings." He'd photoshopped a pair of wings onto his body. It could have looked weird, but somehow it didn't.

"I have an umbrella, in case I need a soft landing." His collage, or artistic statement, whatever you want to call it, was perfect. It summed up who he was and how this camp would help him to grow as a photographer.

"Ready?" I asked. "Three, two, one!" Whether it was the countdown, or that he was tired of stressing about it, Scout pressed the button. We both let out sighs of relief. "You made the right choice," I said, and meant it.

CHAPTER 14

The next day, Scout and I were on the front steps of Umbrella House. We spent a lot of time out there. When we were younger, it was where we did our sidewalk chalk art, scootered, and roller-skated. Nowadays, it made a great location for video shoots.

Scout stood a few feet away behind the camera on its tripod and cued me with a countdown, mouthing, "Three, two..." and then pointed at me for one. As soon as he did, I gave a wide smile and spoke to the camera. "If there was a mayor of the East Village, it'd be Lenny Rizzoli. One of the original Umbrella House squatters, he loves sitting on the front steps of the building talking about the early days. He's seen this neighborhood change a lot over the years."

I stopped when Scout said, "Cut!" He watched what

he'd recorded, listening to the audio though his head-phones. We liked to keep the takes as spontaneous as possible, but we always did a couple of rehearsals to check lighting and sound quality. Once we were rolling, we didn't stop. If a siren went off while we were film-ing, we went with it. After all, that was part of living in New York.

"That works," Scout said, nodding approval. Lenny had been off to the side watching us rehearse, but now he moved to sit where I pointed.

"Like this?" Lenny asked, sitting on the steps with a stiff back.

I wrinkled my nose. "Maybe a little more relaxed." He leaned back so his elbows rested on the stair behind him.

Scout gave Lenny a thumbs up, repositioned the tripod, then took a couple of stills with his phone. "You two are pros, huh?" Lenny said.

Scout held up his fingers and mouthed the count-down. *Three, two, one—*

I gave my hair a quick tousle to loosen the curls and turned a megawatt grin to the camera as the red light blinked on. I ran through the intro again and turned to Lenny. "Can you tell us about the challenges of squat-ting the building?"

One side of Lenny's mouth lifted in a smirk. "That

first winter it was so cold. We had no heat, and the roof still had holes in it. We had to light fires in oil drums in the middle of the hallway to keep warm."

"Yikes," I said. "That sounds like a fire hazard."

"There was no plumbing either. All we had was a bucket for a toilet. This one night, I woke up and was looking for my flashlight. I was moving around and smack! My foot knocked over the bucket."

I cringed, imagining the mess he'd have to clean up. Gross.

"I scrambled around for my flashlight. When I turned it on, there was nothing on the ground. Everything in the toilet bucket had frozen solid! That's how cold it was in the building!"

Scout stifled a laugh behind the camera. "That's disgusting!"

Lenny shrugged like it wasn't a big deal. "Hardship made this building, this whole neighborhood, what it is." Lenny's eyes roamed up and down the street. It was easy to see how proud he was of the East Village.

"Sounds like you miss those days," I teased. I didn't. I was very happy to have plumbing and heating.

"They bonded us, you know? This building and the people who live in it, they're my family. We made this neighborhood. That's why when developers buy buildings to tear them down, it breaks my heart."

I waited a beat, digesting what Lenny had said. "This community is worth fighting for, you know?"

"Yeah, we know," I said.

Scout stopped recording. We couldn't have scripted Lenny's speech better if we'd tried.

Lenny's words were still ringing in my ears as I made my way up to the roof later that night. Monique had called an emergency meeting for tonight at 7 P.M. We rarely had emergency meetings. An anxious tension filled the air as everyone arrived. Even Ortiz was frowning, and he was never in a bad mood.

Amanda rushed in. She'd closed the gallery early to be here and sat beside Grandma and me, giving my hand a squeeze as she did so. "Thanks for encouraging Scout to send in the application," she whispered. I shrugged away her gratitude, wishing I'd been upfront with him from the beginning. "It's kind of a double-edged sword, isn't it? Monique and I hope he gets in, but we don't want him to be gone all summer either."

Amanda glanced in his direction, already looking forlorn. During the summer we hung out at her gallery. She paid us in ice cream or movie tickets to paste up posters for her events. One more thing to add to my

list of things Scout would be missing. "You'll have to come hang out with me whenever you can. So I don't get lonely." She said it jokingly, but I also knew Amanda and Monique's door was always open to me even if Scout wasn't there.

"Okay, let's get started," Monique said brusquely. "Nina Dalmonte, the director of Save Our Neighborhood, called me about an hour ago. There's no easy way to say this, so I'll just spit it out.... Thanks to Gotham Development, the City Council is going to vote on dissolving our co-op. They found a loophole in our agreement. If it passes, Gotham could buy our building."

There was a moment of shocked silence. Grandma squeezed her eyes shut and muttered something under her breath. A prayer, maybe. Then, the comments started to fly.

"How can they do this?'

"Unbelievable!"

"On what grounds?"

"Wait a minute," Ortiz said, holding up his hands. "You said it only happens *if* the City Council approves."

Monique nodded. "Right. The City Council vote is in two weeks and there's a public hearing next week."

"That's so fast. I thought bureaucracy took forever," Amanda said, suspiciously.

"Usually it does. Gotham has a lot of pull with the councilors. Nina thinks they're moving quickly so we don't have time to get organized."

"Typical," Lenny growled.

Grandma pulled her hair into a bun at the nape of her neck and snapped the elastic in place, ready to work. "Tell us about the hearing. Can anyone speak?"

"You just have to apply online."

A flurry of conversation broke out. It sounded like everyone wanted a chance to have their say. "The council's decision will set a precedent for the other former squats," Monique said. "It'll be a domino effect. If we go down, so will they."

"Can we take them to court?" Miguel asked.

"We could start a legal battle, but we've seen how that goes. Mr. Kricklewitz spent the last year fighting and he still lost," Monique said.

"None of us can afford that," Ortiz said. His comment was met with nods from the others.

"I think our best bet is to show the City Council that we're serious about keeping our home. The more of us who speak at the hearing, the better. It'll mean a lot of work, but Van Newell needs to know he picked the wrong building to mess with."

I couldn't believe that our home was under attack, and instead of the City Council protecting us, we had

to prove we deserved to stay. Monique made a list of people who wanted to speak at the hearing. "I want to speak too," I said, raising my hand. Monique glanced at Grandma. Grandma shrugged as if to say, "Like I could stop her." I didn't know what I'd say, but, like everyone else, I wanted my voice heard.

When the meeting finished, the line of tenants heading down to their apartments had the energy of a funeral procession. Even Monique's rooftop optimism had faded. "Saving Umbrella House is going to be a full-time job," Monique admitted.

"It's David and Goliath," Amanda agreed.

"David and who?" Scout asked.

"It's a story from the Bible," Amanda said, turning to look at him. "It's depicted in some famous paintings and sculptures. David was a shepherd boy, but Goliath was a giant warrior with a club as big as a tree trunk. David knew that, in a contest of strength, he didn't stand a chance against him, so instead of lifting his sword, David used his head and his skill."

I hadn't heard this story before either. "What did he do?"

"He got out his slingshot, which looked ridiculous against the might of Goliath. But when Goliath came at him, David aimed the stone right at Goliath's forehead. It hit, and down he went."

"I'm not afraid of going up against someone like Van Newell," Monique said. "He throws his money around like a club, but he should be careful, or he's going to miss the stone headed his way." I caught her drift. A bunch of people living in a former squat seemed like no match for someone with money and power. Someone like Richard Van Newell. We might not have his resources, but we had something else—determination.

CHAPTER 15

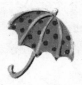

Over the next few days, our two apartments became command central as everyone prepared for the City Council hearing. Our place was where tenants came to collect the handbills Ortiz had designed. I couldn't believe what he'd come up with so quickly. There were three different designs, each with a slogan in his signature typeface. The plan was to paper the neighborhood with them—construction barricades, lampposts, and bulletin boards. If it wasn't moving, we'd glue a handbill to it with wheat paste, a flour and water mixture Lenny boiled up on his stove.

Despite what Scout and I knew about Grandma, we managed to act like nothing had changed. Sure, sometimes I looked at her and did a double take when I remembered that she was the Midnight Muralist,

but for the most part I played it cool. That was how Grandma wanted it, and I had to respect that.

At Scout's place, Monique had tenants making phone calls and going door to door to all the small businesses to let them know what was going on. Umbrella House being in danger motivated our neighbors. They knew that the umbrellas on our fire escape weren't just decorations. They were symbols of the fight it took to make our building into a home and our neighborhood into a community.

All that activity was the fuel Scout and I needed to finish our video for the Veracity contest. Gentrification was an issue that people needed to think about, especially with our building under threat. Every minute we weren't at school, we were researching, interviewing, shooting footage, or editing.

By Sunday we had six minutes of finished video. It was time to show it off.

I cleared my throat to quiet Scout's mothers and my grandma. The three of them were seated in Scout's living room. He and I stood in front of the wall-mounted TV. "Welcome to the premiere of *Future EaVill: How Gentrification is Destroying Our Neighborhood*." There was applause and a piercing whistle from Grandma.

I moved to the side as the *EaVillKids* theme music started. All our videos had the same intro, a close-up

of a map of Manhattan and a graphic of an arrow pointing at our neighborhood. The video cut to drone footage of our block. My narration about the history of the East Village and the squats began, illustrated with Grandma's photos and articles. The video shifted to me giving a quick tour of our building and then the interview with Lenny. We had a clip of Grandma talking about how they'd come up with the name Umbrella House and then a short interview with Mr. Kricklewitz. We had sound bites of kids at school talking about their experiences and a shot of the growing wall of graffiti on Laugh Emporium. Yesterday, Scout and I had gone out at dusk to get footage of *Finding Paradise* and *Concrete Jungle*. I explained how the Midnight Muralist's pieces from twenty years ago were still relevant.

The background music faded to silence as a montage of closed or shuttered businesses filled the screen. The next and last shot was Scout's favorite. He called it "cinematic." It was of me pasting a handbill onto a sidewalk barricade. I walked away, and the camera zoomed in on Ortiz's slogan. *If we don't fight for our neighborhood, who will?*

I knew Scout sometimes felt like wrangling the footage was a never-ending battle. The more he learned about editing and video production, the pickier he was about how he trimmed and joined the frames.

According to Scout, the amateurish jump cuts in our first videos were a dead giveaway that he didn't know what he was doing. Now that he knew how to continue a shot's audio into the next clip, he couldn't watch our early videos without cringing.

When the video finished, no one said anything for a minute. I looked at their faces with my heart in my throat. I thought it was good, but did they? "Well?" Scout asked, breaking the silence. "What do you think?"

Grandma gaped at him. "What do I think?" she repeated. "It's incredible! A work of art!"

I blushed with pleasure and shared a smile with Scout. "Really?"

Monique got up and hugged Scout, then me, crushing us against her. Amanda shook her head like she couldn't believe what we'd created. To be honest, *I* couldn't believe what we'd created. "Watch out, Evelyn Pauls!" Amanda laughed.

I held up a pretend microphone. "This is Roxy Markowski..." I paused and put my "mic" in front of Scout's mouth.

"...and Scout Chang-Poulin..." he said, leaning into it.

"...in the East Village. Speak the truth, hear the truth, find the truth on Veracity!"

Chapter 16

"Another test," I moaned to Scout at the end of school on Monday. I stuffed my math textbook into my backpack. We were in our last month of seventh grade, but the teachers weren't taking it easy on us. "Good thing we got the Veracity video finished."

Sending in the video had been a huge relief. But the day of the hearing was drawing closer, and I didn't have time to relax. What with schoolwork, hitting the pavement to spread the word about Umbrella House, and figuring out what I was going to say in front of the City Council, I was swamped.

But not as swamped as Monique. That was obvious when I went to see her later that night. There were dark circles under her eyes, evidence of many late nights as she prepared for the hearing on top of her day job. She'd

said that saving Umbrella House was going to be a full-time job, and by the look of things, she'd been right.

I'd been working on what I wanted to say, but it was harder than expected. "I don't know where to begin," I lamented. We were sitting in the kitchen. The table was littered with files and papers, highlighters, and half-drunk cups of coffee. "Every time I start something, the ideas fizzle. It never comes across the way I want it to. Explaining why selling our building to a developer is a bad idea needs five hours, not five minutes."

"You need to speak from the heart. Why does Umbrella House matter to you?"

I thought about that. The squatters had been urban pioneers. Tearing our building down, which was probably what Van Newell would do, meant losing a piece of East Village history. But there was more to it than that. "Umbrella House is where my family lives," I told Monique. "And I don't just mean Grandma. It's a refuge, a warm hug on a cold day. It's not only a place; it's an idea."

Monique's face brightened as I spoke. "Roxy," she sighed. "That was beautiful. Tell them that. Your speech doesn't need to be anything but the truth."

I was doubtful. I wanted to believe Monique was right, but I knew how things worked. It was like *The (Real) Big Apple* mural. There were two New Yorks.

One for people like Van Newell, and one for us. Our truths might be no match for Van Newell's money.

I had a week to write something that would convince the City Council that money shouldn't be all that mattered.

"What do you think?" Amanda asked. We were standing outside her gallery looking at a new window display. Scout, Ortiz, Grandma, and Monique were there too. We'd had to drag Monique away from "command central" with the promise that the field trip would only take an hour.

"I love it!" Grandma enthused. The eye-catching signs had been Ortiz's idea. They were so large they filled up the gallery's entire window and were pieces of art in themselves. Each one said the same thing: "Art is the ♥ of the East Village", but each was in a different typeface. He'd used vibrant colors, and the paintings reminded me of the brightest graffiti.

"*New York Style* already reached out for a comment. They want to do a story on how development is affecting artists and gallery owners," Ortiz added. "I let him know about the rally tomorrow."

The rally had been Lenny's idea. He'd booked

some musical acts to play, including his former punk band. Ironically, the band was calld NFA for No Fixed Address, which was what we'd all be if things didn't go well at the council meeting. Scout, a few other tenants, and I would be getting signatures on petitions. Miguel had offered to set up tables for a book swap, which always drew a crowd, and Ulli was collecting clothing for a local shelter. For a couple of hours tomorrow afternoon we'd be showing the city how much the spirit of the East Village mattered to the people who lived here.

"With so much community support, I don't see how the City Council can vote against us!" Grandma said.

Scout snapped some photos of the window signs and a few silly ones of Ortiz and Amanda. He didn't get one of Monique, though. She was staring down the street, and the expression on her face made me wonder if she knew something we didn't.

Would rallies, artwork, signatures, and handbills be enough ammunition against Van Newell? Next Monday, we'd find out.

CHAPTER 17

"This is it," Grandma whispered beside me. Her voice was breathy with nerves as we walked into the wood-paneled room at City Hall. "Nervous?" she asked me.

All I could do was nod. I had my speech typed on my phone, which was getting slick with sweat in my hands. The City Council members were seated at the front on a platform. Each had a gold nameplate and a microphone in front of them. Some of their names were familiar because Grandma had been calling them almost daily.

A list was posted with the speaking order. We'd checked it when we came in. I was fifth, Grandma was seventh. Nina Dalmonte, the woman who ran Save Our Neighborhood, was also speaking. She'd been helping at Umbrella House for the last week. I liked her right away. Not because she was a fan of *EaVillKids* (she'd listed

off some of her favorite episodes)...well, that *and* she was the kind of person who got things done and didn't take no for an answer.

Alex Vickars, the tenth and last name, was one I didn't recognize, but Monique had warned us that Gotham Development would have a lawyer speaking at the hearing as well. When I saw two people, a man and a woman, take seats as far away from us as possible, I knew one of them had to be the lawyer who would represent Richard Van Newell's corporation.

"This public hearing will come to order," the clerk said from his desk off to the side. He introduced the Chair, Ms. Lopez, who was also the councilor for our district, and listed off the rules about keeping our speeches to five minutes and sticking to the order of speakers posted. Scout sat behind me, doodling to calm his nerves. I wished I'd brought something to keep my hands busy too.

Amanda was up first. She was good at speaking in front of people, and she nailed it. She asked tough questions to the councilors about what kind of a city this was—one that allowed hardworking homeowners to get kicked out? Or one that protected them, recognized their artistic contributions, and respected their legitimate rights? Lenny clapped when she finished and was shushed by the clerk.

Then it was Ortiz's turn. He had on his "good" over-alls (the ones without paint spatters), a button-down shirt, and a bow tie. He kept tugging at the collar of his shirt like it was strangling him. "To create, artists need a certain environment. You wouldn't want a chef cooking dinner in a sewer, or a doctor operating in the subway, would you? Well, artists like me need the East Village." He went on to explain how development was robbing the city of its vibrancy and creating an artistic desert. "When we moved to the East Village, the neighborhood was electric. All of the city's energy got funneled through it. Everyone was opening stores, creating venues, starting bands, and making art. These sparks of creativity ignited fires. But now, the neighborhood is changing. Businesses are closing and residents are leaving. The light is dying. The East Village as we know it is going to be snuffed out unless you do something."

I got a lump in my throat listening to Ortiz. He'd spoken from the heart. When he came back to his seat, Amanda hugged him.

Ulli and Miguel followed, each bringing different viewpoints to the argument. Finally, it was my turn. Grandma squeezed my hand and let go when I stood up. The City Councilors probably weren't used to kids speaking at hearings. A few of them gave me

encouraging smiles. I sat down and pulled the micro-phone closer to my mouth.

"Hello." My voice echoed. I cleared my throat and began. My phone was shaking so hard in my hands that I wasn't going to be able to read the screen. I remem-bered Monique's words about speaking from the heart. I took a breath and set my phone, facedown, on the desk, and clasped my sweaty hands in front of me. "My name is Roxy Markowski. I have lived at Umbrella House since I was two years old. It's my home, but it's also my heart. All the people I love the most are within its walls.

"Gotham Development Corporation doesn't know anything about love. It can't, because no company would want to destroy what my grandma and the other tenants built at Umbrella House. What Gotham Development Corporation does know is greed." I paused for emphasis, looking at the council mem-bers. "They see our building, and dollar signs float in their eyes. They want to tear it down and replace it with something new and modern. If that happens, it isn't just Umbrella House that comes down, it's everything. It's the record store, the barber shop, and the diner. Because you can't build a *real* neighborhood on greed and profit, it won't work. *Community* has the word *unity* in it for a reason. Community needs people working together for a common purpose."

A councilor named Mr. McConnell leaned back in his chair and crossed his arms over his chest. The tilt of his head and the smirk on his face told me no matter what I said, he'd made up his mind. Had the others? Ms. Lopez nodded for me to continue. She, at least, was interested.

"I want to be a journalist when I grow up. My hero is Evelyn Pauls from Veracity. Do you know why I admire her?" I paused and looked from face to face. "Because she exposes the truth. There is a dark side to gentrification that is affecting not just my neighborhood, but our city. Sure, there might be a new, modern building where there used to be an old one, but what's inside of it?

"The answer is nothing. No heart. No community. No love.

"Real estate developers need to get the message that our neighborhood isn't for sale, and you're the ones who have to send it. Thank you."

I stood up and walked back to my seat. The adrenaline that had got me through my speech disappeared and I collapsed, limp, against Grandma. She pulled me close and when she gave me a kiss, I felt the wetness from her tears. "That was amazing," she whispered.

"A middle-schooler schooled them!" Scout said, leaning forward.

Lenny spoke next and got pretty worked up.

His voice cracked a few times, when he described all the work, restoration, and maintenance the tenants had put into the building themselves. He banged his fist on the table so hard, water sloshed out of his glass. The clerk cleared his throat as a reminder to keep cool. But that didn't stop his eyes from shooting daggers at the suits in the corner when he returned to his seat.

Then, it was Grandma's turn. She explained about what she did for a living to raise my dad, then me, as a single parent. She talked about struggle and how it bonds people, especially the squatters who made the East Village into a home. "We aren't saying there shouldn't be any development. Of course there should be, but not at the expense of destroying what makes the East Village great."

Grandma gathered up her papers. I gave her a thumbs-up when she turned around. Nina Dalmonte, though not a tenant in our building, spoke eloquently on our behalf and for all the other buildings that would be threatened if Umbrella House were torn down, including her own. She made it clear that Save Our Neighborhood would fight for every single brick of the original squats.

Monique followed and, in true lawyer style, summed up all of our arguments brilliantly, adding a few more of her own. There was just one more person to speak.

"Alex Vickars," the clerk called as Monique returned to us.

The woman I'd noticed earlier stood up. Her hair was pulled into a bun, she wore a crisp navy suit, and she walked like she was smarter than everyone else in the room. "Ugh. She's so corporate," Monique muttered.

Once seated, Alex Vickars opened a leather folio and spread its contents in front of her. She cut right to the chase. "Of course, the tenants want to stay in their homes. They purchased them for a dollar. A dollar! My client recently purchased the building next door. An inspection revealed it needed over two million dollars-worth of repairs to make it livable. I can only imagine what state this Umbrella Block is in, since as Mr. Rizzoli told us, they did the work themselves."

"It gets inspected every year!" Lenny shouted. "Check the records!"

"Mr. Rizzoli!" the clerk said. "Please refrain from interrupting, or you will be asked to leave."

"But she's making it sound like we don't know what we're doing!"

"Sir!" The clerk said, sternly.

Lenny sat down, muttering. His glare at the lawyer was atomic.

Ms. Vickars waited for the Chair to nod for her to continue. "As for all this talk of love and creativity..."

She laughed. "...what dreamworld are these people living in? This is New York. To maintain our city and its economy we need to keep up with the times. Our proposed purchase will mean more tax dollars and an investment in a community, which frankly, is floundering."

"Give me a break," Ortiz said, loudly.

Ulli threw her hands up in the air. "Like you've ever been there!" Even Miguel, who was usually unflappable, growled some curse words.

"You're a liar!" Lenny jumped up, pointing a menacing finger at Ms. Vickars. "Our trouble started when your client moved in, buying up buildings!"

That was all it took for the clerk to motion for the officer at the back of the room. Lenny was escorted out. Monique shook her head. "We look like a bunch of hotheads," she muttered.

"As you can see from the community members behind me, they can't be trusted. It's time for the grown-ups to step in, handle things, and try to make the East Village into a place hard*working* New Yorkers will want to call home."

At that comment, my jaw dropped. "Did she just say what I think she said? How dare—" I tried to stand up, but Grandma put a hand on my arm and pulled me back down.

"It's what she wants," she hissed in my ear. I silently fumed as my blood boiled. Is that what the councilors thought too? Based on a few of their smug expressions, I knew it was.

"My client has a proven track record of neighborhood improvements. I've given each of you a copy of the developments he's completed. He's not greedy, as the youngest, most naive tenant would have you believe."

Naive? She made me sound like a silly little kid. I balled my hands into fists so tight, the skin across my knuckles turned white.

"Mr. Van Newell built his company from the ground up. While others were making art, he was building a business. He's the embodiment of the American dream." A couple of the councilors nodded in agreement with Ms. Vickars. She gave a self-satisfied smile and slapped the folio shut. Every one of us stared in stunned silence.

Ms. Lopez leaned forward and spoke into the microphone. "Thank you, everyone, for your comments. That concludes tonight's meeting. The councilors and I will take all of this into account before we vote. We appreciate your interest and commend your desire to speak today."

Eight tenants, plus Nina, and a concerned activist from another squat had spoken. But were our words

enough against Ms. Vickars and a Goliath-like Gotham Development? Instead of the stone from our slingshot hitting them between the eyes, it felt like they'd swung their club and batted the stone right back to us.

CHAPTER 18

"I thought it went...well," Grandma said. I caught the pause before she said *well* and knew she doubted her own words.

"Until Ms. Vickars spoke," I said. There was no sense pretending. We all knew the lawyer's speech had sunk us. "She made it sound like we were a bunch of lazy do-nothings."

"Well, *we* know that's not true." Grandma hugged me to her as we walked to the bus stop across from City Hall. This area of New York felt like a different city. The sidewalks and streets were wider here, but the tall buildings made me feel small. There was graffiti-free concrete everywhere. Even the people mirrored the concrete with their gray suits and stony expressions.

Scout and his mothers were still on the steps of

City Hall talking with Miguel and some of the others. Ortiz ran to catch up to us. His bow tie was stuffed in a pocket of his overalls, and the top buttons of his dress shirt were undone. "That crack about artists," he shook his head. "Did you see the councilors' faces? Especially that one guy with the hair—like, was that a wig, or a toupee? He wouldn't even look at us when she was done talking."

"That was Dan McConnell." Nina had joined us too. "He votes against every anti-gentrification regulation we've tried to pass."

"So, what do we do now?" Ortiz asked. The bus pulled up, and we stood aside as passengers spilled out.

"Keep calling your councilors and raise public awareness," Nina said. "If the vote doesn't go our way, every other squat that went co-op is going to be in the same situation. Other than that, all you can do is wait."

It was our turn to climb on board. Grandma and I tapped our Metro cards and found two seats together. Ortiz stood beside us, holding the rail above. Nina's advice didn't sit well with me. I wasn't good at waiting.

Grandma reached over, entwining our fingers. "You did good today," she said.

"So did you." But I couldn't help wondering what the councilors would have said if they'd known my grandma, Selena Markowski, was the Midnight Muralist.

We got off at our stop on E. Houston and Ridge St. Another building had come down. Grandma's face fell when she saw the empty space. "Wasn't that Woo's Dumplings?"

Nina nodded. "Came down last week."

"It's like an epidemic," Ortiz said. The empty lot was surrounded by plywood barricades covered with posters announcing art shows, concerts, and upcoming events. An entire section of the wall had been covered with one version of Ortiz's handbills. A fist was raised in one corner with "Stop Whispering. Start Shouting!" written in Ortiz's mix of sloppy brushstrokes and handwriting. It was a strong graphic, made all the more powerful with so many of them pasted side by side. It hit me then that all the work we were doing wasn't going to make a difference to the City Council members. Besides Councilor Lopez, who lived here, when did any of them come down to the East Village? They could have been living on Mars for all they really knew about what life was like in our neighborhood.

The rest of the week passed in a blur. The summer heat had settled in, making everyone feel sluggish. Even

with the AC unit running full blast, Scout's narrow room was stifling.

"It's too hot to do homework," I groaned, pushing my binder away. My hand was sweaty from gripping the pen and the pages were limp from the humidity.

Scout tapped a pencil against his paper. He'd only done three of the science questions. He was having trouble concentrating too. And it wasn't just the heat. The top three videos were going to be announced on Veracity tomorrow! Every time I thought about it, my stomach did a flip.

I picked up a paper from Scout's desk and waved it in front of my face, enjoying the momentary breeze. It wasn't until I put the paper down that I realized what it was. In bold, black type the heading on the glossy feature sheet read For Rent: Spacious Two-Bedroom Apartment. I checked the location. "Brooklyn?!" My breath stalled.

Scout nodded. "Mom and Maman went to check it out."

"And?" I gulped. Brooklyn was at least a thirty-minute subway ride away, maybe more. I slumped in the chair. The thought of what would happen if we lost the vote and Umbrella House sold was inescapable.

Scout gave a helpless, one-shoulder shrug. "They said it was nice. But, you know, it's not the East Village."

I shoved the feature sheet aside. Scout's mothers weren't the only ones looking. Syd and Ulli had checked out loft spaces in Red Hook and Ortiz was thinking Central Harlem if he could get studio space there. Miguel was considering moving into the back room of his bookstore.

"I can't imagine not being neighbors," I said. "We couldn't do *EaVillKids*...go to the same school..." My voice caught on the avocado-sized lump in my throat. Possibly losing Scout for the summer was bad enough, but if he moved all the way to Brooklyn, what would that mean for our friendship?

Scout didn't say anything. He looked up at the photo of us from last summer at the beach, laughing as the waves crashed against our shins. It was hard to believe we'd been that carefree only ten months before.

CHAPTER 19

"Why haven't they posted anything?" I asked at lunch, drumming my fingers on the table. I had my phone in front of me and kept refreshing the site.

"You're going to wear out the refresh button," Scout warned me. We'd found a table away from our friends, but I could feel their eyes on us, waiting for good news.

Ignoring Scout, I tapped again and did a double take. In the last few seconds, the homepage had changed. *Veracity.com Young Voices Contest* ran across the top of the page. "They're up!" I'd been waiting for this moment, but now that it was here, I was terrified. What if our video wasn't there? What if we weren't in the top three?

I slid the phone across the table. "You check!"

Scout positioned the phone so we could both see

it. He read the blurb under the title. "Congratulations to the top three entries in the Veracity Young Voices Contest. Viewers will have a week to vote for their favorite. The winner will be announced in a live feed on Veracity.com next Friday." He looked up at me. My body was rigid with nerves. I wasn't sure I was even breathing.

"Ready?" he asked. His finger hovered over the screen, poised to scroll up. I nodded.

I didn't pay attention to the other names or titles of videos; I only looked for ours. Scout passed one and then—

"We did it!" I whispered. It was right there, in print. *Future EaVill: How Gentrification is Destroying Our Neighborhood* by Roxy Markowski and Scout Chang-Poulin.

I blinked. When I opened my eyes, our names were still there. We were in the top three! I slapped my hand over my mouth so I wouldn't scream and let out a muffled squeal of delight. Scout fist pumped the air and stood up to give me a high five. "Let's go!" he shouted loud enough to get the attention of the lunch supervisor.

I could breathe again. "I can't wait to tell Grandma!"

"My mothers are going to be pumped. They'll get everyone at their work to vote for us."

After everything we'd been through lately, it felt

good to have something to celebrate, especially before the City Council vote.

Scout picked up my phone again to check out our competition. A deep crease appeared between his eyebrows. The table vibrated as he jiggled his foot.

Oh, no. "Bad news?"

"Take a look at what we're up against," he said and passed me my phone. The title of the first video was *Roll with Me* by Gemma Steinman. The second was ours, and the third was—No! Was I seeing this right? *We Have to Gentrify to Beautify* by Pasha Kamal.

"What? How could...but...what?!" I looked at Scout. He was as shocked as I was. Someone had claimed the exact opposite of us!

Word spread about the Veracity contest and for the rest of the afternoon students and teachers kept coming up to congratulate us. All along, I'd been focusing on making the top three, but now I had a new goal: winning.

Underneath my excitement, nerves prickled. I needed to watch the other videos, especially Pasha Kamal's, to see what we were up against. When the bell rang for dismissal, all I could think about was rushing home.

Scout must have been anxious to see the videos too, because when we got to his apartment, he didn't stop in the kitchen for a snack but went directly to his room. We pulled our chairs up to the computer and Scout tapped it to life.

Gemma's video, *Roll with Me*, was about living as a teen with a disability in New York City. She'd filmed a regular day in her life to show the difficulties she faced. It was powerful, and she spoke well. Through Gemma's eyes, New York was filled with barriers. I didn't think anything of hopping on a subway to get somewhere, but it wasn't so simple for Gemma. Only a few stations had elevators. Just getting inside a building was tricky, since not all of them had automatic door openers. She had to rely on others to help. Her video showed a side of the city that I'd never noticed before, and it had been right in front of my eyes.

"Wow," I said when it was finished. "That was really good."

"Ready to watch the next one?" Scout asked.

I nodded, already gritting my teeth. I won't go into the gory details, but watching the video made me angry—as angry as I'd been when Van Newell's lawyer had made that hard*working* comment at the council meeting. Pasha claimed that for a city to prosper, it needed rejuvenation, and upper middle-class people

fueled that by moving into run-down areas. He had interviews with businesspeople and new-to-the-East-Village residents who were, in his words, *changing the face of the neighborhood.*

It was true they were changing it, but not for the better.

"It's even worse than I expected! It's totally biased!" I ranted when the video ended. "He didn't interview a single longtime resident or business owner!"

Scout winced. "We didn't show the flip side either."

"Why would we? What's good about gentrification?" Sure, we could have asked Van Newell for an interview, but there was no way a guy like him would talk to us. I crossed my arms. "I wish I could meet this Pasha and explain a few things," I said, glaring at the screen.

"We believe our side because of where we live, Roxy, but I bet there are lots of people all over the city who think like Pasha. Look at the new condos. They sell out before they're even built."

"That's because they don't understand the impact of gentrification. *They're* the people who should be watching *our* video!" I'd assumed Evelyn would be against gentrification, but maybe I was wrong. Had she picked Pasha's video because she wanted to start a discussion on gentrification, or because she agreed with him?

"Well, Pasha sure knows how to produce a video.

It might not have the impact of Gemma's or the heart of ours, but it's well-made. I can understand why it was picked to be in the top three."

"I'm not saying it's a bad video, it's just not accurate." Pasha argued that buildings that didn't meet code weren't safe to live in and should be torn down. He also pointed out that a growing population in our neighborhood meant more customers for local businesses. Both points were true, but his video didn't give the whole story. Buildings that were torn down were replaced with high-end condos, which the original tenants couldn't afford. Local businesses faced rent increases, or their leases didn't get renewed. Lots of times, new residents weren't interested in supporting them anyway.

Between the two points of view, I knew which one I agreed with—obviously. One week from now, we'd find out what the rest of New York thought.

Chapter 20

Over the next couple of days, I scrolled through Gemma's and Pasha's socials, curious about who we were up against.

Gemma had a big online presence. Most of her posts were related to social justice. She was involved with lots of initiatives and, according to her bio, was heading to college in the fall. I had a feeling Gemma was our main competition, but that didn't stop me from also checking out Pasha's socials, which were compelling in a whole different way.

He was a few years older than us, and his dark hair had a carelessly tousled look that probably took three styling products and a blow dryer to achieve. There were model-perfect shots of him outside shiny glass buildings, in fancy restaurants, and—wait for it—shaking

hands with Councilor Dan McConnell! In all of them he held a sign with #VotePasha on it. I typed in the hashtag and, sure enough, it had a following.

This wasn't a grassroots video about a fresh New York voice. It was a slick marketing campaign. Losing the Veracity contest would suck, but losing to Pasha's pro-gentrification video would be devastating. I couldn't let that happen. If Pasha had found a way to spread the word about the contest through his social media, then I could too.

Like with a lot of things that were decided by the public, drawing attention was a surefire way to win votes. The question was, how? We had our YouTube subscribers and there was a link to vote posted in our bio, but we needed something more—something that screamed East Village. Something that only a kid who'd grown up at Umbrella House could pull off.

I rewatched our video on the Veracity website. Ten seconds in, the perfect idea came to me.

"Where are you off to?" Grandma asked, looking up from the pile of receipts on the table in front of her. Bookkeeping was her least favorite part of running a business, but hiring an accountant was too expensive.

"I need to talk to Ortiz," I said. I was out the door before I heard Grandma's reply. I ran barefoot down the two flights of stairs to his first-floor apartment.

If Miguel's apartment still had a squatter vibe to it, Ortiz's was the opposite. It looked like he'd lived in it forever. There was barely an inch of wall space not covered with art—his own and other people's. Ortiz didn't believe in chairs, so colorful floor pillows were strewn across patterned area rugs. He used stacks of books and old suitcases in place of tables. We'd built some epic forts in this room when I was little.

"I need your help with something," I said when he opened the door.

Ortiz loved spontaneity. I could have said, "Let's host a Saturday afternoon pillow fight in Tompkins Square Park," and Ortiz would have said, "Okay." Luckily, my idea was closer to home, and right up his alley.

Ortiz hooked his thumbs through the straps of his overalls as I explained. His eyes lit up. "I love it!" he said when I finished. "We'll need everyone's permission, though."

"I'll send out a text in the group chat."

"Perfect. I'll get the supplies and meet you at my studio after school tomorrow." He held his hand up for a high five.

I pounded back upstairs, giddy with anticipation and ready to spread some #UmbrellaLove.

The one hiccup to my plan with Ortiz was that Scout wouldn't be able to join us. He was busy after school with the annual TSMS Showcase. All the media studies classes put their best work on display in the library. It opened at lunch today and ran for two days.

"Welcome," Mr. Clovis said when I walked in at lunch break. He handed me an iPad so I could scan the QR codes under each exhibit to see a video of the creator explaining their work. As cool as all the pieces were, I was here to see Scout's photographs. He'd told me they were at the back, in the silent reading alcove. I went straight there, bypassing a cool graphic design display of silk-screened T-shirts and an even cooler stop-motion animated film. Scout had dressed up in a polo shirt and gelled his hair to keep it off his face. I couldn't remember the last time I'd seen his whole forehead.

The library was beginning to fill with other kids. I was glad I'd gotten here when I did. Scout had been given the alcove because he had more than one piece to display. He had a whole collection.

"Hey," he said when I arrived. The chairs and tables had been moved so the space was empty and felt like a gallery. Instead of a QR code, there was a small card

under each of his framed pieces with the title of the photo and the date it was taken, just like at Amanda's gallery.

"Where do I start?"

"Here, I guess." He pointed to the photo beside the entrance. Other kids hadn't made their way back here yet, so it was just the two of us.

The first picture was titled *Kricklewaltzing.* Mr. Kricklewitz and his wife were dancing outside their store while a busker with a blue mohawk played a violin. The Store Closing signs in the background gave it a melancholy feel. In another photo, some big-name punk band had started an impromptu concert on the roof of Vinyl Trap. Word had spread, and by the time Scout got there a crowd of fans had gathered, spilling onto the street. Scout must have held up his camera to take the photo, because a sea of heads and flailing arms was in the foreground.

And then there was the graffiti wall at Laugh Emporium. It had become the neighborhood message board to city councilors and developers. This photo was in black and white, making the words look ominous.

"That one looks familiar," I said, pointing at another black-and-white photo of people moving out of the apartment building next door. Furniture and mattresses were tied down with ropes on the back of a

pickup truck. A person with a forlorn expression leaned out the window. It looked familiar, and after a minute I realized why. "It's like one of those pictures from the Great Depression." We'd seen similar images last year when we were learning about that time in history.

"That's what I wanted!" Scout beamed, pleased that I'd made the connection.

The photos weren't just pretty pictures. They told stories. What I tried to do with research and interviews, Scout did with his camera. "I can see why Mr. Clovis wants you to go to the camp. These are so good, Scout!"

Scout did a great job filming our *EaVillKids* videos, but these photos were something else. Any lingering hope that he and I would spend the summer together disappeared. The director of the Lens Photography Camp would be a fool not to accept him.

Kids were finding their way to Scout's installation. There were bursts of laughter and tiny gasps of surprise. *Kricklewaltzing* got the most attention because everyone knew Mr. K, and we were all sad to see him go. Before I moved on, I glanced back at Scout. He looked confident as he gestured at his work and explained the photos. A little twinge in my chest told me that the path Scout needed to be on included a camera by his side—instead of me.

CHAPTER 21

Ortiz's studio, in a building a few blocks away on E. 10th St., was a huge open space with paint-spattered hardwood floors. When Scout and I were younger, Ortiz used to bring us here on rainy weekends to ride our scooters or create art. *Papier mâché*, glitter dust, finger paint—nothing was too messy.

"How's this?" I asked, holding up my first completed umbrella.

Ortiz appraised my work. While I'd been at school, he'd collected eight of the umbrellas from the fire escape and brought them to his studio. He'd already finished painting a couple with bold, colorful designs, inspired by the Nuyorican art movement. Mine was more basic. I'd painted *#UmbrellaLove* and multi-colored hearts. Each umbrella was going to spread

the word about the Veracity vote with messages like *#VoteUmbrella @Veracity.com.*

"Looks great," he said, adding black outlines to his shapes.

"What do you think will happen with the City Council vote?" I asked. I set aside the completed umbrella and picked up another one from the floor. Ortiz had cleaned all of them of dust and left them open on the floor to dry. Brushes sat in coffee cans along a low table near the sink. Canvases lined the walls, and the smell of acrylic paint filled the air.

Ortiz sighed. I knew that sound; Grandma made the same one whenever I asked her. "I think they're probably split down the middle. There's bad blood between squatters and the city that goes way back. They've never understood the squatting movement. They look at us, at what we did, and they see freeloaders, not revolutionaries."

"Or maybe they do see revolutionaries, and that's what scares them."

We worked in silence for a while—well, as silent as it can get in a studio on E. 10th near St. Mark's. On the sidewalk below, buskers, pedestrians, and traffic filled the air with familiar neighborhood noise. Ortiz didn't play music while he worked; he said the sounds of the city were what he needed for inspiration.

Ortiz and I created our own rhythm inside his studio. There was the tap of paintbrushes against the paint jars and the sound of bristles gliding across the slippery umbrella fabric. It was easy to get into a zone as I focused on making each umbrella unique and colorful.

"That's my last one," I proclaimed, setting it down on the floor with the others. I'd been so intent on our task that I hadn't noticed the time.

"Let's grab dinner," Ortiz suggested. "By the time we're done, the umbrellas will be dry, and we can take them home."

Ortiz led the way to the tall windows that lined the front of the studio. They looked out onto E. 10th. He hefted a window up and climbed out onto the fire escape. I followed, and he shut the window. As we clattered down three flights, the metal grates bit into my thin-soled shoes. At the last level, Ortiz lowered the ladder that would take us to the sidewalk. "After you," he said. It's technically illegal to use a fire escape this way, but it was one of those laws that didn't carry weight with people who'd lived in the neighborhood for decades.

I climbed down to the pavement. Ortiz did the same and gave the ladder a shove that sent it clanging up and out of reach. "Where to?" he asked.

Mama's Kitchen, the Cuban place, was across

the street. So was Grandma's favorite spot for curry, India Palace. My stomach grumbled for either. As I considered my options, a silver town car pulled up to the curb a few feet ahead of us. I did a double take when I saw the license plate. "Ortiz!" I hissed, tugging his sleeve.

He peered at where I pointed. "Is that—?" Only one person could have a license plate that read VANNWL. The rear door opened, and a man with slicked-back, graying hair emerged. A gold watch glinted at his wrist. It probably cost the same as some people's yearly rent. "What's he doing here?" I asked. As he strode to the office a few doors down, we got our answer. He was going to Councilor Lopez's constituency office. "Ortiz?" My voice shook. "What do you think is going on?"

Ortiz shook his head and looked crestfallen. "She was the one councilor I thought was on our side," he muttered. My earlier question about how the vote would go had just been answered. If Van Newell was able to use his money and influence to convince Councilor Lopez to vote against us, what chance did we have?

Not even the heat of India Palace veggie curry could get rid of the bad taste that seeing Van Newell had left in

my mouth. Had Councilor Lopez sided with the opposition? What had been the point of a hearing when our own councilor could be wooed by Van Newell? I said as much to Ortiz as we walked home carrying all the umbrellas.

"Don't jump to conclusions," Ortiz advised. "There's no law against developers meeting with city councilors." But the words rang hollow. He was as worried about what we'd seen as I was. "Anyhow, you need to stay focused on winning the Veracity contest. Using the umbrellas was a great idea." When Scout and I had been working on the video, it hadn't occurred to me that if we lost Umbrella House, winning the contest would be meaningless. Instead of a documentary report on Umbrella House, we'd be filming an obituary.

CHAPTER 22

It didn't take long for word to spread about who Ortiz and I had seen going into Councilor Lopez's office. Monique had been holding tenants' meetings often to keep everyone informed on the latest developments. All anyone wanted to talk about at today's meeting was Van Newell. Monique rubbed her temples, trying to keep the meeting from spiraling. "Van Newell's visit might not have been related to Umbrella House. He has lots of projects on the go."

Lenny snorted. He'd already jumped to worst-case scenario. "What good is having a city councilor when she backstabs her own constituents?" he fumed. As hard as Monique tried to convince everyone to keep an open mind, the mood in the building slid to an all-time low. Even Umbrella House seemed to sag

under the hopelessness, as if the building itself knew that fighting was futile.

Grandma had finally surrendered to the fact that moving was a possibility. A pile of newspapers sat on the kitchen counter, with potential apartments circled in red. More than once I caught her staring into space, a worried look on her face.

I tried to stay focused on the conversation swirling around me, but the future of Umbrella House wasn't the only thing on my mind. The winner of the Veracity contest was being announced this evening at seven o'clock.

The newly painted umbrellas and #UmbrellaLove had gained our video some attention. Earlier in the week, a reporter from *The East Villager* blog had done a story on us. "YouTube Darlings *EaVillKids* Set Sights on Veracity" was the headline. In the back of my mind, I kept thinking about Pasha's posts and how polished they were. It was obvious he didn't have to worry about rising rents or losing his home.

"Not hungry?" Grandma asked. We were back at the apartment and, no matter how good her homemade pasta sauce was, all I could think about was the announcement

Evelyn Pauls would deliver in less than thirty minutes.

I pushed spaghetti around on my plate, making a little nest of noodles and keeping an eye on the time. "Sorry, Grandma," I said finally, pushing my plate away.

She gave me a sympathetic smile. I'd been a jangle of nerves all day at school too. This contest was made for me—and I knew that what we'd submitted had hit a nerve. Lots of people in our neighborhood had told me so.

I checked the time on my phone. Less than an hour until the winner was announced. I washed the dishes and volunteered to do laundry. Anything to take my mind off the excruciating, slow passing of minutes. Finally, at ten to seven, I went to Scout's apartment.

"Do you want us to watch with you?" Amanda asked when she greeted me at the door. Monique, as usual, was at the table working. Scout and I shook our heads.

"You'll hear if we win," he said.

"You'll hear if we lose too." My stomach was doing cartwheels, and I was glad I hadn't finished the plate of spaghetti.

The veracity.com website was already open on Scout's computer. A countdown timer showed the time left until the live feed began. "This is it." Scout rubbed his hands together like he couldn't wait to get started.

"I'm nervous," I admitted in a small voice.

When the countdown clock hit 00:00, Evelyn Pauls' face filled the screen. She was in the Veracity newsroom, her gold hoop earrings glinting through her mass of dark curls. Behind her, people sat at computers and talked on phones.

"Good evening, New York! I'm live at the Veracity studio to announce the winner of our Young Voices Contest. I said I wanted to hear from young people in New York City, and boy, did I!" She laughed. "From the hundreds of submissions we received, we narrowed it down to our three finalists. Gemma Steinman looked at New York through the lens of people living with disabilities. Roxy and Scout showed us the effects of gentrification on the East Village, and on the flip side, Pasha Kamal explained why gentrification has been wrongly vilified. I think all the contestants inspired New Yorkers to consider what they want for the future of our city. But now, the moment you've been waiting for....The winner, as selected by *your* votes, is..." she paused dramatically.

Scout gripped the arms of his chair. I closed my eyes and silently whispered, *Please, please, pl—*,

"...Gemma Steinman!"

I froze as Gemma's name echoed in my head.

Evelyn kept talking. I watched her lips move without hearing anything she said.

We lost.

We actually lost.

After a few minutes, Scout turned down the volume and looked at me. "You okay?" His voice sounded far away. The nerves that had me wound tight started to unravel.

I raised one shoulder in a slow, deliberate shrug, still too numb with shock to know what I felt. I hadn't just wanted the win; I'd wanted this opportunity. Working and learning from Evelyn would have been the first step to my dream job. Now all of that, *everything I'd been hoping for*, had been ripped away from me. "I can't believe it's not going to happen."

Scout shook his head. "That's not true. It's going to happen, Roxy. Just not right now."

Was it though? If I couldn't win a contest like this one, did I have a chance at making it for real? My hope of following in Dad's footsteps and one day thanking Grandma for all she'd done shrank before my eyes. It was that thought that brought the tears.

"There is some good news," Scout said. I couldn't imagine what it was. "At least Pasha didn't win."

I smiled, even as I wiped away tears with the heel of my hand.

"And also, think of all the people who didn't know anything about our building, or who'd never considered

how gentrification affected people. We might have opened thousands of people's eyes."

I appreciated his positive spin, but none of what he said took the sting out of the loss. I stood up, slowly. "I'm going upstairs," I told Scout. "I need to be alone."

He nodded, understanding. "We may not have won, but it's still the best video we ever made."

He was right, but his words didn't make me feel any better. *Our best just wasn't good enough.* It was a bitter realization. On my way out, Amanda and Monique hugged me, telling me how proud they were of what we'd done. "Thanks," I muttered and then trudged up the stairs and into Grandma's waiting arms. She'd been watching the results too. I buried my head against her shoulder. "It's okay," she whispered. "Let it out."

I really cried then. Not with drops that trailed delicately down my cheeks at Scout's, but with hiccups and snotty sobs. When I was ready, Grandma guided me to my room and tucked me into bed, promising I'd feel better in the morning. I fell asleep hoping she was right.

CHAPTER 23

Did I feel better the next morning? The shock had worn off, but all I wanted to do was stay in my pajamas, watch Netflix, and feel sorry for myself. I couldn't even find the energy to go for a walk with Scout and Hank.

I tried not to spiral, but I couldn't help reminding myself that Scout still had the possibility of the photography camp. After yesterday's contest results, I had nothing to look forward to.

With a miserable sigh, I slouched lower on the couch, grateful for the latest binge-worthy reality show. But then a jackhammer started up and my hope of drowning out the world faded. Grandma had sent me a text reminding me to shower and eat. As roadwork shook the apartment, now was a good time to do both.

When I emerged fifteen minutes later, I did feel better. It was amazing what some hot water did for my spirits. I pulled my wet hair into a bun and went into the kitchen. I was finally hungry enough to eat and dug through the fridge for leftovers. Grandma had assured me that over time the sting of the loss would fade. "You'll regroup and attack your dream a different way," she'd said before she'd left for the flea market. *What way?* There weren't tons of options for kids my age.

I knew sitting and wallowing wasn't helpful. Neither was another episode of a reality show. I was about to text Scout to see if he'd taken Hank for his walk yet when I noticed a paper on the floor. Someone had slid it under the door. I picked it up and recognized Scout's printing.

Michael Jordan was cut from his high school basketball team.
Jay-Z was turned down by every major record label.
Walt Disney's first film studio went bankrupt.
Roxy Markowski lost Veracity's Young Voices Contest.

I smiled at the last one, not sure I belonged in that list of incredible people. It was nice to know Scout had so much faith in me. Underneath the list was a quote:

My failures didn't define me, they inspired me.

When I saw who'd said it, my smile grew.

Evelyn Pauls.

It was hard to imagine her failing at anything. But I guessed no path to success was without its bumps.

When Grandma had been consoling me last night, she'd told me about the time my dad had been working on a story no one wanted. Every newspaper and magazine in New York turned him down, but he kept digging and writing, confident that it was a good idea.

"He started sending it other places and finally a paper in California bought it."

"Which one?"

"The *L.A. Times!* That was the story that launched his career. He moved out there and worked for them. If he'd given up," she held her hands up in a shrug.

I thought of Grandma and the murals. She hadn't put her signature on the first ones she'd done. Thank goodness *she* hadn't given up. If she had, there'd be no Midnight Muralist.

I looked at Scout's list of failures and decided it might not be such a bad list to be on.

Scout's head was bent over the camera Mr. Clovis had given him. He'd asked me to join him outside so he could practice night photography. The low light required a slower shutter speed and a larger aperture, whatever that meant.

I hadn't spent the day wallowing after all. It still sucked that we'd lost. Like, really sucked. It was true that winning the Veracity contest would have been a shortcut to getting where I wanted to be, but Evelyn hadn't made it by winning a contest. Like my dad, she'd become a success through hard work. If she could do it, I wanted to believe I could too.

"Did you know that Evelyn Pauls didn't start at Veracity?" I asked Scout. He was fiddling with a dial, and I wasn't sure he was even listening. "Her first job was with a local blog in the Bronx. Then, she moved around working in Miami, Los Angeles, and San Francisco before coming back here."

Reading Evelyn's bio had shown me that if I was going to make it as an investigative reporter, it wasn't going to happen overnight.

"So," I paused dramatically, excited to tell Scout what I'd done. "I e-mailed *The East Villager* to see if they wanted a summer intern."

"You did?" Scout looked up from his camera for a second. "That's awesome!"

I nodded excitedly. "They might say no. I mean, I'm only twelve years old—"

"But with your experience, they might also say yes!"

The contest hadn't worked out, but I wasn't going to let my dream go. This was New York, after all, a city built on dreams. I wouldn't let one setback crush my spirit. If I did, I'd never get anywhere.

CHAPTER 24

The summer humidity had arrived earlier than usual and settled in like a hot, wet blanket. I wrinkled my nose at the air's distinctive summer scent. Heat turned dumpsters into garbage ovens and pulled long-buried odors out of the pavement.

All day at school I'd pushed the future of Umbrella House, my e-mail to *The East Villager*, and Scout's photography camp to the back of my mind. But as I walked home after drama club, my worries crept back in.

The City Council vote was next week. No one was confident that it was going to go well. Monique was looking into legal options, such as getting an injunction which would stall the process, if the councilors sided with Van Newell.

Sometimes I looked around the East Village and

wondered what it was going to look like in ten years. If Umbrella House was bought, it meant no building was safe from developers.

Well, that wasn't totally true. The buildings with Grandma's murals weren't going anywhere. She hadn't known she was protecting them, but that's what had happened. Each mural had become an iconic piece of the East Village and no building owner or developer dared tear them down—they mattered too much to the neighborhood. If only she'd painted a mural on Umbrella House. If she had, we wouldn't be locked in a battle to save it.

A mural on Umbrella House…! I stopped walking—a big no-no in the middle of a busy sidewalk. The man behind me *tsk*ed and did a quick sidestep. I didn't bother to mutter an apology. My mind was spinning too fast to walk *and* think.

Why hadn't I thought of this before? The answer to our problem had been right in front of us this whole time.

I picked up the pace and race-walked the rest of the way home.

I was red-faced and breathing hard when Scout opened the door. I hadn't bothered to go up to my place and drop off my backpack. I could feel all the places my T-shirt was sticking to my skin thanks to the summer

humidity that had settled in and never left. Before he could get out a greeting, I said, "I know what we can do to save Umbrella House!" I stepped inside Scout's apartment.

"What?" Scout asked.

"The sixth mural!"

He frowned, not following. "Do you have heat stroke?" he asked, genuinely concerned.

"No!" I was almost giddy now that the idea was taking hold. "We could paint it. On Umbrella House. Even if Van Newell was allowed to buy the building, he couldn't tear it down, not with a brand-new piece by the Midnight Muralist. Maybe he wouldn't even want it! Think about it. All the buildings with murals are safe, protected by Grandma's art. If we did one on Umbrella House..."

Scout nodded with understanding. "But Selena hasn't painted in decades. Are you sure she's going to want to go along with this?" I'd considered his misgivings too. The whole walk home, actually. I kept coming to the same conclusion.

"I think she'd do it to save our home."

"Okay, let's say we convince her, then what? We just start painting?" I knew what he was getting at. The power of the murals wasn't just their message, it was also the impact of their sudden appearance.

I paced up and down the length of the apartment. "We'd have to do it the way she did." I'd already told Scout how Grandma had managed to work without anyone knowing. It was one more secret she'd have to share with the tenants if this was going to happen. "It'll come down to time. Could we finish it before the City Council votes? Her other murals took weeks, depending on when she could paint. We only have ten days."

"If all of us help and we work around the clock, we might pull it off before the vote."

I jumped at the possibility. It was risky, but if it worked...I didn't want to let myself hope. Not yet. "I have to convince Grandma," I told Scout.

Scout was antsy and eager to help. "I could make a video to explain what we want to do. *If* she agrees, we can show it at tonight's tenants' meeting." Scout's eyes were shining. "This could work, Roxy."

I thought so too, but I didn't want to get ahead of myself. Everything hinged on Grandma saying yes.

"Oh, goodness. It is *steamy* outside!" Grandma exclaimed when she joined me at our apartment twenty minutes later. She'd tied a bright head scarf around her head to keep the perspiration from dripping in her eyes. Fanning

herself, she went to stand in front of the AC unit.

"How was drama club?" she asked.

"Good." I took a breath to steady myself. There was no point in delaying what I had to say, so I charged ahead. "I came up with a really good idea. I think it might save Umbrella House."

"Oh? What is it?" Grandma asked. She lifted her chin so the AC would blast her neck.

I swallowed. "A mural."

Grandma turned to look me full in the face and put her hands on her hips. The answer was going to be a hard no before she even heard the whole plan. I had to speak fast.

"Before you say anything, just hear me out. We could get everybody to help and keep it hidden, just like you used to. None of the tenants are going blow your cover, Grandma. The best part is, even if the City Council votes against us, Van Newell would never dare to tear down a building with an original Midnight Muralist piece on it."

"Roxy...sweetie...you know I can't do that."

"Yes, you can!"

"That part of my life is over." She said the words gently, but firmly. "It's in the past, and that's where it needs to stay."

"This isn't about the past, Grandma. It's about the

future. *My* future." I let those words sink in. "If we lose this building, we'll have to find a new place to live. All your savings, everything you've worked for, could be gone in no time. And who knows where we might end up? Life as we know it in the East Village will be over." Grandma's face tightened. What I'd said had hit home.

Grandma shook her head, obstinate. "It wouldn't work. Back then, it was—I was—different. Those murals represent a different person."

"That's not true! You're still that person! At the hearing, you talked about how much Umbrella House meant to the neighborhood. How can you walk away from it when you have the power to save it?" I waited a beat and continued. "We already have the design. Miguel had your sketchbook—the one with a sketch for a sixth mural. He's had it all this time." Grandma's mouth hung open. I kept going. Momentum was on my side now. "It's amazing! It deserves to be on a building, not hiding in a sketchbook. You're an *artist*." I dropped my voice and met Grandma's eyes. "You can't erase who you are. You need to reclaim yourself. For me. And for you too."

I'd thought speaking at the City Council hearing was the most important speech I could give, but I was wrong. It was this one. I'd said all I could. I just had to hope it was enough to convince Grandma.

Chapter 25

The heat made a meeting on the roof impossible, so we moved it to Scout's apartment, which worked out well for us. He could upload the latest video to *EaVillKids* and keep the setting private so only we had access to it. Then, when everyone was there, we'd show it to them.

Of course, none of that would matter unless Grandma agreed. I had left her sitting at the kitchen table, staring at the sketch for the sixth mural.

Grandma had told me to go ahead without her because she needed time to think. It was all up to her now.

There was none of the usual chatter when I entered Scout's apartment. Lenny stood at the back, too agitated to sit. Ulli sat beside Syd on the couch, holding a glass of ice water to her forehead. Ortiz was cross-legged

on the floor, fanning himself with a folded handbill. Miguel was working, so he would arrive late. I beelined for Scout, who stood beside Amanda near the kitchen. He raised his eyebrows in a question.

I shrugged, wishing I had an answer. "Did you get the video finished?"

"Yeah.... I hope we can show it."

I did too. Everyone pulled chairs into a *U*-shape and angled them toward where Monique stood in front of the TV.

The meeting was about to start. I cast a nervous look at the door. Wasn't Grandma coming?

Monique cleared her throat, ready to begin. The door opened. Miguel entered, and behind him was Grandma. "Sorry we're late," Miguel said. Ulli shifted over and patted the couch to make room for Grandma. Miguel came to stand beside me and *winked!*

What did *that* mean?

He leaned in so only I could hear him. "I bumped into Selena on my way up. She told me your idea. I don't know how you did it," he said, shaking his head.

"You mean...?" I looked at Grandma. She gave the smallest nod.

"She said yes!" I whispered to Scout, barely able to contain my excitement. Our plan was a go!

Monique only got out another two words before

Scout said, "Uh, Maman, can we show everyone some-
thing, please?"

"Now? Can it wait until I'm done?"

"We think you're going to want to see it," I said,
trying to contain my excitement.

"Okay." Monique sighed. "Go ahead."

I took a breath and began. "There's another way to
stop Van Newell," I said. "It still means fighting, but
East Village style." I looked at everyone's faces. Their
curiosity was piqued.

Scout had the remote and turned on the TV,
locating our YouTube channel. The *EaVillKids* theme
music started, and a shot of the building appeared. It
was the same beginning as on the Veracity video. There
was quiet laughter when Lenny's face filled the screen,
and it got louder as he told the toilet bucket story.

But then it cut to the part Scout had added today.

"All the things that give the East Village character,
like community..." Scout cut to footage of people
hanging out at Rocky's Barbershop and Laundromat,
"...activism..." a shot of the anti-gentrification graffiti
on the wall of Laugh Emporium, "...and art..." Ortiz's
window signs at Amanda's gallery filled the screen, "...
are at risk. Or are they? What if the things that make
the East Village special, like community, activism, and
art, are also what we can use to save it?"

The final shot was of our building. Slowly, an overlay of the sixth mural, the one that had never been painted, appeared. Faint at first, then brightening, the colors came to life in all their vibrant glory. Scout had scanned the sketch, and it probably took forever to get the effect right, but the result was stunning.

The credits rolled, and I looked at everyone, triumphant.

Silence.

Ortiz and Ulli glanced at each other, but the interest they'd had when the video started was gone. No one congratulated us on coming up with a great idea. Lenny gave a hopeless snort. "So much for that," he muttered.

"Thanks for trying," Ortiz said, and gave us a sad smile.

Across the room, Amanda nodded. "I love that you're thinking outside the box. That mural you photoshopped onto Umbrella House *is* incredible." Amanda paused for a moment. I resisted the urge to side-eye Scout. *Has she figured it out?* "But the stakes are too high for a mural to make a difference."

"What if it was painted by someone famous like the Midnight Muralist...that'd be different, right?" Scout asked.

She laughed, because to her that was still an

impossible idea. "Of course! A new piece by the Midnight Muralist would change everything," Amanda said.

I risked a glance at Grandma. She was avoiding eye contact by staring at her hands and spinning the bracelet on her wrist.

At the window Lenny nodded. "Remember how it used to feel to hear another mural had been found?" He laughed under his breath. "We'd all rush over there to check it out, like Christmas morning had come early." Lenny's gravelly voice was even lower than usual, filled with awe. "The Muralist spoke up, and people listened. I wonder what he'd say about what's happening now?"

After Lenny's words, it took every ounce of self-control I had not to jump in. *Say something, Grandma!* I silently pleaded.

"I could tell you," Grandma said quietly. "I know exactly what the Midnight Muralist would say."

Lenny gave her a funny look. "You do? How?"

"Because—" Grandma's voice caught. "Because..."

"Come on," I murmured, willing her to finish the sentence.

"Well, because I'm the Midnight Muralist."

Her words were followed by the longest silence of my life. Finally, Ulli broke it. "She's joking," she laughed.

Grandma looked around the room. "I'm not." Her face was deadly serious.

Ulli's smile faded. She blinked at Grandma. "You're not?"

Grandma shook her head, apologetically. "I wanted to tell you—"

"Why didn't you?" Lenny interrupted. Everyone in the room stared at Grandma, waiting for her response. The shock I'd felt when Miguel had told me was on their faces now.

"Because...well, I loved seeing your reactions. You just said finding a new mural was like Christmas had come early. I didn't want to ruin that. There aren't many *good* surprises in life." She gave a quiet laugh. "The murals were something I could give to you. All of you."

No one spoke until Ulli said, "Selena is the Midnight Muralist!" She looked at everyone, the joyful flush in her cheeks almost matching the pink of her hair. "How did we not see it?"

Ortiz's mouth hung open. He shook his head in disbelief. "The murals were done at night. We would have known if you left...." Then his eyes widened behind his glasses. He slapped his hand to his forehead. "The cleaning job!"

A tiny smile pulled at Grandma's mouth as she nodded.

Monique was confused. "What cleaning job?"

"She used to work nights cleaning office buildings.

Sometimes, she'd work every night for a month. At least that's what I thought!" He turned back to Grandma and pointed a finger in her direction. "That's how you did it without us catching on! For a while, I thought you had a gambling habit!" He snickered. "You were working so much, but there was never extra cash!" His comment brought laughter and a snort from Lenny.

"I can't believe it!" Monique said. Like the other tenants, she looked at Grandma in wonder. "How did you create murals without people noticing? Behind scrims, like everyone thinks?"

Grandma nodded. "I hung up fake permits to make it look legit. Sometimes I'd hire a crew to help set up the scaffold and pay them cash. I used to wear a disguise to keep my identity a secret. No one ever questioned the scaffold, or the scrim. It was just one more construction project. As for who'd paid them," Grandma shrugged. "It all became part of the mystery."

"Why did you stop?" Ulli asked.

Grandma glanced at Miguel. "Sam and Miguel found out. Sam was worried I'd get caught. The laws kept getting tougher. I didn't know what would happen to him if I was arrested, so—"

Ortiz held up his hands, pausing the conversation. "Whoa, whoa, *whoa! You* knew she was the Midnight Muralist? And you kept it a secret?" He glared at Miguel.

"I had to! I didn't want to get in trouble with Selena!" There were some chuckles. Sometimes I forgot that when Miguel was my age, Grandma had been like a second mother to him.

There was a long silence. "I still can't believe it," Lenny said, scratching his head. "You were the Midnight Muralist."

"Not was, she *is* the Midnight Muralist," Ortiz corrected, grinning. "You never stop being an artist."

"That's right," I said, stepping forward. I loved watching everyone's reaction to the news, but I'd stayed quiet long enough. "The mural at the end of the video was Grandma's, one she never got around to painting. It's what can save Umbrella House. I know normally a mural would take weeks, but if we all work on it in shifts, we can finish in days." The energy of the room went up a few notches.

Amanda's eyes shone with gallerist glee. "A new piece by the Midnight Muralist! Selena, if you—we," she corrected, "manage to pull this off, it'll be the biggest piece of subversive art since Banksy's *Balloon Girl*."

"We'll have to round up the supplies. Rent them, I suppose?" Monique was already tapping at her phone, making a list.

"I have to warn you. I haven't held a paint brush or a can of spray paint in so long."

Amanda gave her an understanding smile. "Like Ortiz said, you don't stop being an artist. Creating is like breathing to artists. You can do this, and the kids are right. With all of us helping, ten days will be enough time."

Monique made a doubtful noise in her throat. "It'll have to be done sooner than that. For maximum impact, we need people talking about the mural. Unveiling it the day of the vote is cutting it too close."

"When do you want it finished?" Grandma asked.

Monique didn't hesitate. "Sunday night. Can you do it?"

"Sunday," Grandma repeated. Her expression wobbled, hovering close to skepticism. But as quickly as it appeared, it shifted. She set her lips in a determined line. "I guess I don't have a choice. Not if we want to save our home." An excited cheer erupted. There were hugs all around, and lots of high fives for Scout and me. But now the pressure was on, and nobody was going to feel it more than Grandma.

CHAPTER 26

The atmosphere in the building had completely changed now that we were taking action. I stopped worrying about the meeting between Councilor Lopez and Van Newell. Even if they were working together, the two of them were no match for the power of the Midnight Muralist. Everyone was energized and excited to get started.

Except Grandma. "What if this doesn't work?" she asked Ortiz later that night in our apartment. They were sitting at the kitchen table with the design for the sixth mural between them, tweaking the original sketch.

"It will!" Ortiz and I said together.

Grandma laughed at our answer. It was too late for her to back out now anyway. Just like when they'd renovated Umbrella House, jobs had been assigned

to everyone. Ordering the scaffold and overseeing its setup was given to Lenny, since he had the most experience in construction. Ulli was making a schedule to divide up the painting duties. Amanda was handling the scrim rental, and Monique was getting permits— real ones—because she had a connection at the city permit office. Miguel would talk to Mr. Kricklewitz and ask if we could use his roof to set up the scaffold.

Grandma had decided to do the mural not on the front of the building, but on the exposed exterior wall on the north side, above Laugh Emporium. Miguel didn't want to lie to Mr. K, but he couldn't tell him what was really going on either. Secrecy was key if we wanted this to work. "I'll say it's for a necessary improvement to the façade," he decided.

Of course, Mr. Kricklewitz agreed. He spent most of his day in front of his store chatting with passersby. With the store shelves empty, his stream of customers had fallen away. More than once, I'd caught him staring at the graffiti on the front of the building and wiping away tears. Among the protest messages were messages of support. *We'll miss you! EV won't be the same without you.* I wished we could tell him that we were planning to Kricklewitz Van Newell. No one would have appreciated it more than Mr. K.

A truck with the scaffold arrived early Wednesday

morning, the soonest we could have it delivered. To abide by all the safety permit regulations, trained professionals set it up. With so many of us working on the mural at once, we needed a safe site. The last thing anyone wanted was to get shut down, or worse, injured. Just like when Grandma had painted at night, the mesh screen, or scrim, would cover the scaffold and conceal everything behind it.

"I can't believe we have to go to school," I complained to Scout. Grandma said we had to do things as normally as possible, to avoid suspicion. The clang of the poles and clack of wooden platforms followed us down the block. I looked longingly at what the workers were setting up and wished that we could stay where all the action was.

Scout had been unusually quiet since we'd left the building. We walked almost half a block before he spoke.

"I got an e-mail from the director of Lens Photography Camp last night."

My breath caught in my throat. *He waited until now to tell me?* "And? Did you get in?" It was impossible to guess from his expression. If it was a yes, wouldn't he be more excited?

"Yeah, I did."

You knew this might happen, I reminded myself. "Congrats! That's great news!" I forced cheer into my voice, willing my face not to betray me.

Scout gave a wry laugh. "Thanks for pretending you're happy."

"I'm not pretending. I *am* happy for you. I'm just not happy for *me*." I sighed.

"I haven't accepted yet." He cast me a sideways glance and it was full of indecision. "I know it's a great opportunity, but—"

"No buts, Scout. To get better, you have to push yourself, leave your comfort zone. Isn't that what Mr. Clovis said? If I, of all people, think you should go, what does that tell you?"

"That you're trying to get rid of me," Scout joked.

"It's only for six weeks," I reminded him. It would feel like forever because it was summer vacation, but I didn't add that.

"It's not just that." Scout's voice was glum. "What if we lose the vote? I can't go to Washington, DC if it's our last summer together at Umbrella House."

"Yes, you can," I argued, but Scout cut me off.

"You know I can't. There's no way I could leave. That's what I told the director too. I explained what was going on and asked if I could let her know after the vote."

"What did she say?"

"I haven't heard back yet."

I blew out a puff of air. There were so many things

wrapped up in the City Council's decision. With only days to go, I wanted time to stop *and* speed up. Until the vote results were announced, the status quo stayed the same. But once the fate of our building was decided, things were going to change for us—one way or another.

Chapter 27

I leaned out Grandma's bedroom window, watching her work. Her worries about not painting in so long had disappeared as soon as she stepped onto the scaffold. With a can of spray paint in her hands, she looked invincible. I took a minute to admire her bravery and boldness.

"You should be in bed," she said, catching sight of me. Her voice sounded Darth Vader-ish because of the mask she wore to protect herself from fumes.

I rested my elbows on the sill. I couldn't sleep if I tried. "Did you miss painting?"

Grandma wiped the back of her hand across her forehead and pushed the mask up. The gloved tip of her index finger was black from the spray can's nozzle. "I didn't realize how much until today," she said.

Once the scaffold and scrim had gone up, painting had begun almost immediately. Ulli had scheduled shifts starting at 6 A.M. for the early risers and ending at 1 A.M. for the night owls. All through the day, two, sometimes three, people were on the scaffold working on their section of the mural.

"You know, being up here makes me think of your dad."

"In a good way?"

She smiled. "Always."

She beckoned me forward. "Do you want to help?"

Of course I did. Monique had warned both Scout and me that we weren't old enough to be on the scaffold, but now wasn't the time to remind Grandma of that rule. I crawled through the open window to get to the scaffold platform. With the scrim shielding us from the street, it was like being inside a cocoon. An industrial work light was aimed at the wall, casting our bodies into long shadows and making it feel like there were more than just the two of us up there. Grandma held the can of spray paint out to me. A clipboard held her design in a clear, plastic sleeve. Pencil lines divided it into a grid that matched the one drawn in chalk on the wall. Each section was labeled with a letter. Instead of envisioning the entire mural, she only had to focus on one small part at a time. "Here," she said, handing me the spray can and the mask.

I checked the design and mapped it out with my eyes, making an imaginary line on the wall. Holding up the can, I pressed. The paint sprayed out with a hiss. I held my arm steady, moving it slowly as I followed the arc of the design. "That's it," Grandma said. "Nice and even."

When I was done, I took a step back to survey my work. It wasn't as good as Grandma's, but it wasn't bad either.

Grandma stood beside me, surveying my work. She nodded approvingly. "The apple doesn't fall far from the tree."

"Maybe let's not talk about falling while we're on a scaffold," I teased.

Grandma gave me a long look. Her face had turned serious. "No matter what happens, Roxy, this is your home. It's where your dad wanted you raised. It's why he brought you here after you were born. Even if they take us out of Umbrella House, they can't take Umbrella House out of us. Do you understand what I mean?"

I nodded. It was hard to separate who I was from where I lived. The two things were so entwined.

Grandma glanced at the time and her eyes widened. "You really have to get to bed. You've got school tomorrow."

As I crawled back through the window, I looked back

at Grandma. She'd pulled the mask over her face, once again lost in her art. Without Umbrella House, who would either of us be? I hoped I never had to find out.

The next few days passed in a blur. A constant patter of feet danced across the scaffold platforms. Ulli was a drill sergeant with her schedule, and no one wanted to mess things up by missing a shift—or face her steely-eyed glare of disapproval. Scout and I were allowed to work on the bottom section of the mural because we didn't need to be on the scaffold. Sadly, it was also the most boring part. Just the black silhouette of buildings in a skyline that we painted on with rollers. As the work progressed, Grandma and Ortiz discussed how to approach certain parts of the mural. Grandma always got final say, but I liked hearing Ortiz's take on things; how he challenged and pushed her. The two of them sounded like Scout and me when we worked on a video.

I didn't see Grandma much, except when she came in for a shower or to grab a meal. As exhausted as she must have been, passion for the project shone on her face. It was like a veil I had never noticed was lifted. I thought Van Newell's lawyer, and her crack about

hardworking citizens. She had no idea what hard work meant.

I hadn't heard back from *The East Villager* yet, and I was trying not to let it get me down. Scout assured me the editor I'd e-mailed was probably just busy, but I wasn't so sure. Maybe they didn't need an intern, or worse, when they read that I was in middle school, they'd deleted the message.

"There you are!" Grandma said as she came into the apartment. She was in a pair of worn, paint-spattered jeans and a baggy T-shirt. A bandana held her hair back, but there were turquoise and yellow streaks of paint in it too. "It's almost done," she said. "A few finishing touches and we'll be ready to take down the scaffold tonight. Right on schedule."

I couldn't wait to see the whole thing completed. A design on paper was nothing compared to a mural that took up one side of a building.

"Are you happy with it?"

I shuffled over so she could sit beside me. Our couch was "well-loved," with some spots on its plush purple velvet more worn than others, but it was pure comfort with its rounded arms and deep seat cushions. It let out a soft sigh when Grandma sat down. She leaned her head back and stretched her legs so they rested on the coffee table.

"I am. It's what I envisioned twenty years ago." She turned to face me. "It feels right that I'm painting it now. Like it was meant to be."

"Maybe it was," I said, nestling closer to her. By taking the sketchbook and giving it to Miguel, Dad had unknowingly made this possible. In a way, he was with us now, helping to keep Umbrella House our home.

Chapter 28

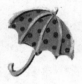

Just after midnight, word spread that the mural was ready to be revealed. For the past few hours, I'd heard the clatter of metal poles and the slap of the wooden planks as they were piled on the sidewalk so they could be picked up in the morning. All that was left to do was drop the scrim.

"Ready?" Scout asked when I met up with him in the hall outside his apartment. He'd been tasked with watching Hank, who knew something big was going on. He was as antsy as we were to get outside.

I was too nervous to answer. What if a new mural by the Midnight Muralist didn't get us the attention we needed? There was nostalgia attached to the old murals around the East Village. A new one might not mean much to the changing neighborhood.

"This is it!" Scout said, and I knew he meant more than just the mural. The director of the photography camp had e-mailed him back and told him they'd hold his spot until the vote. The reality that things were soon going to change for us one way or the other sat in the back of my mind like a storm cloud.

Miguel was at the front doors, directing traffic. A few people had already gone to the roof to drop the scrim. The rest of us were to wait silently on the sidewalk. We didn't want to attract attention just yet. Hopefully the mural would do that in the morning.

Nighttime New York on a Sunday was peaceful. The streets were virtually empty. Streetlamps illuminated the sidewalk, casting eerie shadows. When Grandma had been painting, this setting had been her studio. I could imagine the sudden quiet empowering her, energizing her in a different way. Alone on the scaffold, she must have felt like the night belonged to her.

I went directly to where Grandma was standing. Her eyes were bright, shining with excitement. She put one arm around my shoulder and squeezed me to her. "Thank you," she whispered into my curls, then planted a kiss on my temple.

"For what?" I asked.

"For giving this back to me." She waved a hand at the

still-hidden mural. "I've found myself again." Her voice cracked.

"You can't cry yet," I teased. "We haven't even seen the mural!"

"I can't help it. All of this has been a whirlwind. No, a hurricane." She was laughing *and* crying, maybe more from exhaustion than anything else.

Miguel gestured for us to join the others in front of Laugh Emporium. Bathed in the glow of moonlight, the mural would finally be visible.

Ulli, Lenny, and Syd were on the roof, waiting to drop the scrim. We had to stay quiet, so the countdown to the reveal was a silent one. We held up our hands with three fingers raised, then two, then one. The scrim fell to the ground in a slither of fabric.

And that's how *Be the Light* saw the light. Everyone gasped. It. Was. Incredible.

Better than the sketch, even! A flock of birds, painted in geometric shapes in pastel-tinted hues, took flight. Along the bottom, above the skyline Scout and I had painted, were the words *One beat of wings does nothing, but thousands can change the world.* Around the edges of the mural, shadowy figures encroached, beaten back by the flutter of the birds' wings.

Grandma's crescent moon signature was just below my window, kissing the sill.

No one clapped, but there was a silent celebration. Lots of hugs and muffled laughter. Hank joined in with a howl that made everyone laugh and shush him. The mural was magic. Not just because of its message, or that it was by the Midnight Muralist, but because it embodied Umbrella House: what we stood for and what we believed in. We'd done this. We'd created it together. Standing on the sidewalk, surrounded by Scout, Grandma, and all the other tenants, I closed my eyes to savor the moment.

But it wasn't a victory. Not yet.

As much as the mural was a celebration of what could be accomplished when a community worked together, it also depicted what happened when we didn't. Saving our neighborhood was an ongoing battle between community spirit and corporate profit, struggle and privilege. In a city like New York, this fight could go either way.

It hit me as Scout and I arrived yawning and bleary-eyed at TSMS on Monday morning that this was our last week of school as seventh graders. If the vote didn't go our way, maybe it would be our last week at TSMS.

Everyone around us was hyped about the last few days of school, but all I could think about was the

mural. When would it be discovered? Again, Grandma had refused to let me stay home. Now, more than ever, protecting her identity was essential. Pleading ignorance about the mural was going to take every bit of acting skill I had.

We were at our lockers when Scout passed me his phone. "Take a look." *The East Villager* had posted a story and photo of the mural with the heading "Midnight Muralist Makes His Mark!"

"*His* mark," I muttered to Scout. I wished I could set them straight, but Grandma said it was better if people thought she was a he. It made her even more invisible. Still, the assumption was irritating. Pushing that thought out of my head, I read the article, biting the insides of my cheeks to stop a smile from spreading.

This morning, a new mural by the Midnight Muralist, the first in twenty years, appeared on Umbrella House. The former East Village squat is currently fighting for its life against real estate developer Gotham Development Corp. A City Council vote on Wednesday will determine if the building will be the next victim of gentrification. It's possible that this mural will do what so many people have failed to do: score one for the good guys.

"Oh my gosh," I exhaled.

Scout didn't bother trying to hide his grin, so I didn't either. After weeks of worry, and then days of painting and wondering if we'd make the deadline, the mural was done. It was drawing the attention we needed. The Midnight Muralist was back, and *maybe*—just maybe—we'd be able to save our home.

By the time school was over, Veracity and all the major news sites were running stories on the mural. Lenny called it "Midnight Mural Madness". Reporters weren't just talking about the mural, either. They were asking questions, like "How can a developer be allowed to buy Umbrella House?" and "Is everything in New York for sale?"

We had wanted to raise awareness and get people talking, to make it impossible for the City Council to ignore us. It looked like, at the very least, we'd accomplished that. We'd see if it had made a difference once they voted.

Scout and I were on the roof, leaning over the edge. We'd rushed up here after school to take in the melee below. News vans with satellite dishes on top, reporters, and camera people joined the throngs of onlookers curious to see the newest Midnight Muralist art.

They filled the sidewalk and spilled onto the street. All the neighbors, including Mr. Kricklewitz, had come out to join the fray. I rested my elbows on the ledge and let out a satisfied sigh.

We'd finished the mural with time to spare. People from all over were celebrating the return of the Midnight Muralist. Scout was still here, and for the moment, our home was safe. But every minute that passed brought us closer to things changing.

"Is that your phone?" Scout asked. I'd been so lost in thought that I hadn't heard it ring. I pulled it out of my pocket. A number I didn't recognize flashed across the screen. I almost let it go to voice mail. Some of the tenants had been getting phone calls from reporters to see if they'd seen the Midnight Muralist working, or if they wanted to comment on the mural.

At the last second, I realized it could be someone from *The East Villager*. I'd included my cell number in my e-mail, so I answered. "Hello?"

"Roxy Markowski, please." The voice on the other end was business-like. I stuck one finger in my ear to hear better.

"Speaking."

"This is Jaya Khan from veracity.com. I'm Evelyn Pauls' assistant." I turned to Scout my face frozen in shock. "Roxy, are you there?"

"Um, yes, I'm here." My voice came out in a squeak.

"Great, okay. Evelyn wanted me to reach out to you. She's been following the Umbrella House story and saw you speak at the City Council hearing. She was impressed." My mouth went dry. *I* had impressed Evelyn? Good thing I was already sitting, or I would have fallen down.

"Who is it?" Scout mouthed.

"Evelyn's assistant!" I whispered back. Scout gaped at me for a second and then moved in close. I held the phone away from my ear so he could listen too.

"I know you were a finalist for the Young Voices Contest. We really loved your energy and the video. So, we were wondering if you'd agree to go on-air with Evelyn the day of the vote. You and," she paused, "Scout, right? You two are a team?"

A *team?* The word echoed in my head. Through everything that had gone on, we'd supported each other and worked together, even when our goals were going in different directions. "Yeah, we're a team. Sort of a package deal," I said, grinning at him.

"Great! So, can you both join us at City Hall on Wednesday?"

Scout grimaced. Being on camera wasn't his thing, but I wasn't doing this without him. "Please?" I mouthed.

On the other end of the phone, Jaya cleared her

throat. I didn't want to keep her waiting, or give her the impression I wasn't interested. I looked at him with pleading eyes. Finally, he relented.

"Okay," he said. "Let's do it."

Chapter 29

People walked up and down past us on the stairs at City Hall. I barely noticed them because all my attention was focused on Evelyn Pauls *who was standing right beside me!*

She was shorter than I thought she'd be, and more fine-featured than she looked on TV. A breeze tousled her mane of curls. I got goosebumps every time I realized we were going to be part of her report. Between our video, the mural, and the upcoming vote, Evelyn had realized there was a story here. She'd done some digging, starting with what was behind the rush to get this motion passed. Was it just Van Newell's influence, or was more going on?

She'd investigated each of the councilors. It turned out Van Newell had been courting all of them, not just

Councilor Lopez, and some of them had made deals that were, well, not strictly legal. If the vote went against us, and Evelyn went public with her findings, things were going to get nasty. *Really* nasty. It didn't mean Umbrella House would be safe—another developer could still swoop in. But Evelyn had a feeling that what she'd discovered would definitely start a bigger discussion about the possibility of bribery and whose interests City Council was considering. I pushed Evelyn's investigation out of my mind for now and focused on the camera person standing a few feet away. The bulky video camera resting on his shoulder was aimed at us.

Grandma, Scout's mothers, and the rest of the tenants from Umbrella House were watching off camera. This was live, and if the vote went badly and Van Newell won, I didn't know what I was going to say. I didn't want to consider that possibility.

But if we won—get ready for some whooping and hollering! Evelyn touched the device in her ear. "My assistant inside says the results will be announced any minute," she said, and nodded to the camera person. A red light blinked on. She looked at Scout and me. "Ready?"

I took a breath and held it, too anxious to let it out. Scout and I stood shoulder to shoulder. He wrapped his pinkie finger around mine and squeezed. Evelyn began speaking, her voice strong and sure.

"The fate of the former East Village squat known as Umbrella House is in the hands of City Council. Moments ago, they voted on whether or not the building, now a co-op, should be accessible for purchase. Before we hear the results, I'd like to introduce two Umbrella House tenants, Scout Chang-Poulin and Roxy Markowski. Roxy, fill us in on what the tenants have been doing to save the building."

The thought of millions of New Yorkers watching stalled the breath in my throat. Evelyn gave an almost imperceptible nod of encouragement, and it was all I needed. I lifted my chin and gazed into the camera. The words began to flow.

"We spoke at the hearing two weeks ago and have been going door to door to raise awareness about the impact of gentrification. We've handed out leaflets, papered the city, and collected names on petitions at a rally. We also made a video for the contest at Veracity. We lost, but you know, can't win 'em all."

Evelyn smiled and shifted to Scout. "And the mural that appeared on Monday morning, a new piece by the Midnight Muralist. Great timing." She arched an eyebrow. "Do you think it will sway the City Council?"

I gave Scout's pinkie a you-can-do-this squeeze. "We hope so," he said. "I mean, we're so grateful that a legend like the Midnight Muralist wanted to help us.

That mural reminds people about what makes the East Village, the East Village—and why we can't lose buildings like ours."

"And if the vote is in favor of Gotham Development, what then?"

"We keep fighting," I said without skipping a beat. "Umbrella House means a lot to everyone in our neighborhood. It represents what a community can do. A message has to go out to the developers that not everything in New York is for sale."

"Powerful words from some young voices," Evelyn said. She turned to the camera, put a hand to her ear and gave a quick nod. "The vote results are in, and City Council has voted..." I glanced at everyone who'd joined us. This was it.

I took a breath and held it.

"*Not* to allow Gotham Development..." The rest of Evelyn's words were drowned out by our shouts of joy. There were squeals and cheers and clapping. We'd done it! A group of East Village tenants had fought against gentrification, against redevelopment, against *Goliath*—and won.

CHAPTER 30

That night, everyone at Umbrella House was celebrating. Nina had joined us, and so had Mr. Kricklewitz and his wife.

The two of them were packed up and ready to head to a condo in Florida. I'd been hoping Van Newell would decide he didn't want to buy Laugh Emporium since he didn't get Umbrella House. But I guess there's not much wiggle room in real estate. The deal had gone through and now that Mr. K was used to the idea, he was kind of okay with it. "No more winter!" he kept saying. "And I'll be five minutes from the ocean!" But it sounded like he was convincing himself as much as us. After spending his whole life in New York, living anywhere else was going to take some adjustment.

As relieved as I was that we'd beat Goliath—Gotham—I needed some air. The win today meant our building was safe, but now, there was nothing to stop Scout from going to Washington. I wasn't ready to deal with that fact. For the moment, I wanted to take a beat and savor the victory.

The best place to do that was the roof, but it turned out I wasn't the only one looking for quiet.

"Grandma?" She was standing by the ledge looking out at the skyline. I hadn't noticed her slip away from the party. She motioned for me to join her and wrapped an arm around my shoulders.

"What are you doing up here?" I asked.

"Enjoying what we didn't lose today," she said, smiling. As views went, ours wasn't exactly a postcard, but it was still magical, especially now, as the sun set. "You know, finding out the building was safe wasn't my favorite part of the day."

"It wasn't?" I asked, surprised.

"It was seeing you with Evelyn. I think one day a young girl is going to look up to you the same way."

I flushed at the compliment. *One day, hopefully.*

"I'm so proud of you. Your dad would be too," Grandma sighed. In moments like these, the quiet ones, there was space for his memory to slip in. *This is his win too,* I thought. *The home he wanted me to grow up in is safe.*

Behind us, the door to the roof creaked open. Miguel stepped out. I grinned. He was probably hoping to get some alone time too. "Am I interrupting?" he asked.

"No," I said.

"We were just thinking about Sam," Grandma said.

Miguel gave a soft laugh. "Me too. For these last few days...the mural and everything...I missed him more than usual."

"He would have loved this," Grandma said. "Seeing everyone work together."

"And seeing you paint again. Legally," Miguel added. "That would have made him happy."

Grandma leaned her cheek against Miguel's shoulder. "I hope so," she said.

There was a flutter and whoosh as a pigeon landed on the ledge right beside Miguel, its blue-gray body illuminated by the moonlight. It hopped closer. The three of us stared at it, not daring to move. Pigeons didn't usually come up here, and definitely not at night when they should have been roosting. I expected it to fly away, but it didn't. It stared at us, tilting its head, as if it was wondering why the conversation had stopped.

"Do you think—?"

"It's kind of weird."

I grinned and held out my hand, almost level with the ledge, curious to see what would happen. Would the bird fly away?

No. It hopped closer. I held my breath as it jumped onto my hand. I'd never held a bird before. Its talons poked my palm, but it didn't hurt. The pigeon moved, dancing from foot to foot, iridescent feathers shimmering. None of us spoke. There was nothing to say. The moment was too special.

It ended when the door to the roof slammed open. Ortiz and the rest of the party had found us. Loud, jubilant voices shattered the stillness, and the pigeon lifted off in a flurry of feathers. I watched it go, soaring into the night sky. I looked at Grandma and Miguel. "That was…" I smiled trying to find the words and looked at my hand. Across my palm lay a silvery feather. I held it up to the light.

"…magical," Miguel whispered.

It didn't take long for us to be engulfed by the party. I scanned the roof, looking for Scout, but I couldn't see him. It was time we talked. I wanted to find out if he'd e-mailed the photography camp to tell them he could attend. Maybe he was in his room doing that right now. I snuck back through the door and went down the stairs to check.

But Scout hadn't gone to his apartment. He was

parked on the stairs between our floors. "Hey," I said, sitting beside him. "What are you doing here?"

He shrugged. "Waiting for you. You weren't in your apartment, so I figured you'd have to come this way eventually."

I sat down beside him. "Why didn't you text me?"

"I did."

I pulled out my phone. Sure enough, I'd missed his messages. "Guess I'll have to get better at answering when you're at camp." I tried to keep my words light.

Scout ran a hand through his hair. He shifted his body to look at me. "About that..."

I waited expectantly. I'd known this moment was coming, but I still wasn't totally ready for it. "I don't know if I want to go." His voice hitched, full of emotion. "The East Village is home, you know? Sure, I'll be taking photos, but if I'm not in the place that inspires me, what's the point?"

"But if you don't go—"

"I'll regret it." His indecision filled the space between us. "I wish there was some kind of sign to tell me what I'm supposed to do."

The next words were hard to say, but they were the truth. "I think the vote today *was* the sign. You might not get this chance again. You have to take it."

I grinned and nudged him with my shoulder.

"We can't not do things because they're scary or we're worried we might fail. This camp was made for you." I held up the feather. "I got a sign too," I said and explained what Grandma, Miguel, and I had seen on the roof.

"Whoa. Do you think—?"

I shrugged. It might have just been a pigeon. Or, it might have been my dad letting me know that things were going to work out the way they were supposed to.

CHAPTER 31

Scout had set up a tripod so we could both be in the shot. Since the interview with Evelyn, he wasn't so camera shy. We were sitting on the front steps of Umbrella House, a fitting location for this video.

We were both tanned from our holiday at Sag Harbor where we'd spent the last week jumping waves, searching for beach glass, roasting marshmallows over bonfires, wading in tide pools, and running up and down the boardwalk. Time moves differently at the beach, and we'd made enough memories in one week to last the summer.

Grandma had come with us too. She spent the week painting. That's right, painting. A half-finished canvas sat on an easel in our living room. Working on the mural had reawakened Artist Selena Markowski.

I think painting made her feel closer to my dad too. She talked about him a lot more. Finding herself, the person she used to be, had made his memory come alive for both of us.

"This is the last *EaVillKids* episode for a while," I said, smiling into the camera. "Scout is off to Lens Photography Camp in Washington, DC for six weeks. It's a really big deal, and I know he's going do amazing things."

Scout grinned. Now that he was used to the idea, he was getting excited. Mr. Clovis had been pumped when he'd shared the news, and so had his mothers. Amanda was already talking about doing a young artists' installation at her gallery in the fall. Scout had told her not to get ahead of herself, but I knew he was secretly pleased. With so many people in his corner, Scout was finally starting to believe in his talent.

"And I landed a gig with *The East Villager!*" I'd be starting as a junior intern the next week. The editor I'd reached out to had replied to say she was a fan of *EaVillKids* and would love to bring me aboard. It didn't pay, and I'd be mostly doing odd jobs around their small office, but I didn't care. It was a step toward what I wanted to do.

"This fall we'll be taking *EaVillKids* to the next level. We're going to look at some issues that matter

to us." I grinned at Scout. He was as excited about the new direction as I was. "Until then, this is Roxy Markowski..."

"...and Scout Chang-Poulin..."

"...from the steps of Umbrella House, East Village, New York City. Stay real. Stay EaVill!"

When the red light blinked off, I let out a sigh of relief. "We made it."

Scout stared at his hands. "That was tougher than I thought it'd be."

This was hard, but tomorrow would be worse. Scout's train left Penn Station at nine in the morning.

Scout packed up his equipment and then we stood awkwardly looking at each other. We'd never had to say good-bye before and neither of us wanted to. "I've got one shot left in this roll of film," he said, holding up the old camera he'd bought at the flea market in Sag Harbor. He'd given the other one back to Mr. Clovis when school ended. "Let me take a picture of you in front of Umbrella House."

I expected Scout to go to the end of the sidewalk. Instead, he ran all the way across the street, shouting something about backlighting. "Artists," I mumbled under my breath. A delivery truck trundled by, and then three taxis. We might be here all day while he waited for his perfect shot.

Finally, there was a car-free moment and Scout held the camera up to his face. I gave him my biggest smile. When he looked at this photo, I didn't want him to think about the things he was missing. I wanted him to remember all the things he'd be coming back to. A home filled with secrets and mysteries, love and laughter, family and friends.

Our home at Umbrella House.

THE END.

Author's Note

Umbrella House is a real place. It is located on Avenue C in New York City. Once abandoned, repossessed by the city, and barricaded with concrete, it was first "cracked" in 1988 by a group of people in need of a home. Early residents came and went, but a core group of individuals dedicated themselves to turning the building into a home. Over the years the building was repaired and given the name Umbrella House for the reasons described in this book. In reality, the building is six stories and has eighteen units.

Depending on who you ask, the location of Umbrella House might be in the East Village, or the Lower East Side. It is also (historically) part of Alphabet City. Avenue C is known in Nuyorican, the local Latino dialect, as Loisaida. This name was made official in 1987.

New York City is one of my favorite cities. I lived there for many years, during which my interest in the history of the East Village began. Due to the COVID-19 pandemic, I couldn't return to New York to research this book the way I'd hoped. Luckily, my stepdaughter, Chloe, is a flight attendant and made many trips to New York for work. She took photos and videos and talked to the people I couldn't. A special shout-out to photographer Stacie Joy and the blog *EV Grieve*. I pored over this website daily, savoring photos and reports about the goings-on in the East Village. It made me feel like I was there when I couldn't be.

I also did *lots* of research from my home, and I've included some articles that you can find online if you're interested in learning more. Gentrification and the need for affordable housing is an ongoing issue in cities around the world, and especially in New York. While I wrote this book, rents for active listings in the East Village rose over 40 percent. The influx of people who can afford these rents has changed, and will continue to change, the face of the neighborhood.

It was my hope to convey the heart, spirit, and energy of the East Village in this book. A huge shout-out to the many current and former residents of the real Umbrella House who inspired this story.

All of these articles and books were helpful, but they are written for an adult audience, so not all material is appropriate for young readers:

- https://jacobin.com/2014/04/squatters-of-the-lower-east-side/
- *The Revolution of the Every Day* by Cari Luna (Tin House Books, 2013)
- https://www.sapiens.org/culture/new-york-city-squatting/
- https://bedfordandbowery.com/2015/07/from-squat-to-rooftop-squash-a-new-garden-blooms-at-umbrella-house/
- https://www.amny.com/news/former-squat-goes-from-holes-in-roof-to-a-garden/
- http://www.umbrellahouse.nyc

Acknowledgments

As always, my biggest thank you is to the incredible team at Pajama Press. Thanks to Gail, Erin, Quinn, Simin, Lorena, Liza, and to editor Kathryn Cole for your patience, guidance, and support.

And can we talk about the cover! Peggy Collins is a gifted illustrator and author. I have no words for the joy this cover art brings me. It lifted me when I thought the book might never be "done." Hugs to you, Peggy, because words aren't enough.

I'd also like to thank Kathie MacIsaac for reading this manuscript when I was in the murky depths of this-book-will-never-be-finished despair. Her encouraging words helped me get to the finish line. A few other folks who offered encouragement or insight along the way are Alex McGavin, Kari Tanaka and

Asia, Natasha Deen, Michelle Kadarusman, Sheldon Nelson, James Nelson (for buying me chocolate), Thomas Nelson (for the gift of his presence and for giving me a laugh when I needed one), Cindy Kochanski, Kim Bell, and Mandy Connell.

This book is dedicated to two of my favorite people/authors, Maureen Fergus and Jodi Carmichael. Writing can be a frustrating, lonely experience, but having the two of you by my side makes things infinitely more enjoyable! Cheers to lots more chats, books, and celebrations.

Finally, and most importantly, I'd like to acknowledge the people of Umbrella House and the community they created.

An author and middle-school teacher, **Colleen Nelson** earned her Bachelor of Education from the University of Manitoba in her hometown of Winnipeg. Her previous works include the critically acclaimed middle-grade novels *Harvey Comes Home*, *Harvey Holds His Own* (a finalist for the Governor General's Literary Award), *Harvey Takes the Lead*, and *The Undercover Book List*.